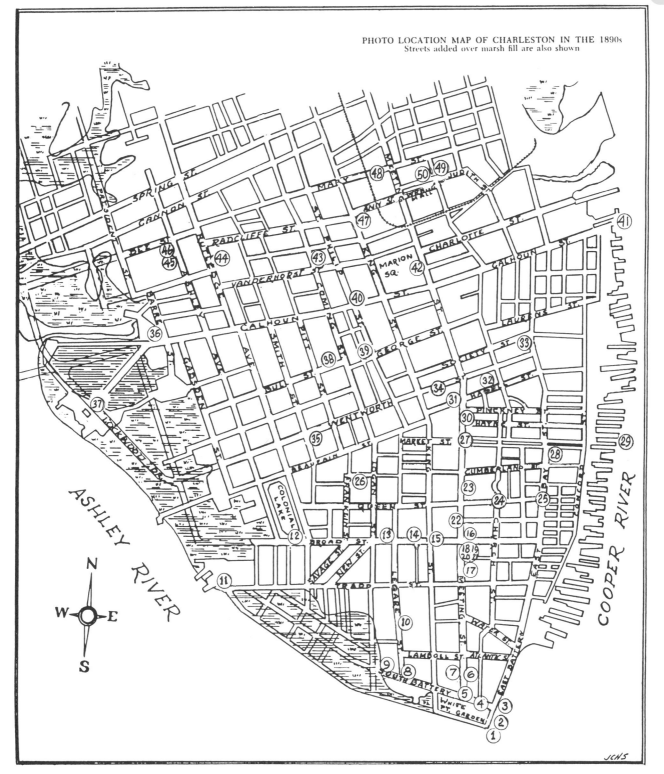

PHOTO LOCATION MAP OF CHARLESTON IN THE 1890s
Streets added over marsh fill are also shown

Charleston
Then and Now

Charleston
Then and Now

contemporary photographs by

Robert Pinckney Rhett (1990s)

James Moore Rhett, III (1970s)

text by

John Carson Hay Steele, Sr.

published by

Sandlapper Publishing Company, Inc.

Published by Sandlapper Publishing Co., Inc., Orangeburg, South Carolina, USA

Book Design by Tiger Creek Productions, Columbia, South Carolina. Typeset in Palatino.

Dust Jacket Design by Catherine Flynn

Printed in Canada

ISBN 0-87844-129-8

Library of Congress Cataloging-in-Publication Data

Rhett, James Moore.
 Charleston then & now / contemporary photographs by James Moore
Rhett, III, Robert Pinckney Rhett; text by John Carson Hay Steele,
Sr. — Rev. ed.
 p. cm.
 Includes index.
 ISBN 0-87844-129-8
 1. Historic buildings—South Carolina—Charleston—Pictorial
works. 2. Charleston (S.C.)—Buildings, structures, etc—Pictorial
works. I. Rhett, Robert Pinckney, 1955– . II. Steele, John
Carson Hay. III. Title.
F279.C48A27 1996 96-4017
975.7'91—dc20 CIP

PREFACE

It is my great pleasure to write the preface for this new edition of *Charleston Then and Now*. It is also an honor for the Preservation Society of Charleston to have this book dedicated to the efforts of our founder, Miss Susan Pringle Frost, who in 1920 initiated the effort to preserve Charleston for ". . . future generations of our own people."

When Jack Steele and Robert Rhett proposed a new edition of *Charleston Then and Now*, the Society responded with enthusiastic support. We believe the book is a tribute to the success of the local preservation movement over the years to keep Charleston, Charleston. The book serves as tangible evidence of what the Preservation Society of Charleston is all about as it ". . . cultivates and encourages interest in the preservation of buildings, sites, and structures of historical or aesthetic significance." The photographs also reveal that in large measure we have been successful in our goal to prevent the destruction or defacement of any such building, site, or structure.

The book is most important as it describes the great contribution preservation has made in providing for the continuity of the place as we know it today. This continuity of place is beautifully expressed in the photographs that image then and now so clearly. There have been losses, as these pictures eloquently attest. However, the photographs of what remains are testimony to the force of the idea that progress can be balanced with preservation.

Through the photographs and text Mr. Rhett and Mr. Steele eloquently reinforce the value of preservation as an activity important to the future, even as it celebrates the past. Most of all, they celebrate Charleston, a city they both deeply love, a city—

> "Beautiful as a dream, tinged with romance, consecrated by tradition, glorified by history, rising from the very bosom of the waves, like a fairy city created by the enchanter's wand. . . . That was, and is, Charleston, thanks to her people's preservation ethic." (from *Guide to Charleston, Illustrated* by Arthur Mazyck, 1875)

John W. Meffert, Executive Director
Preservation Society of Charleston

FOREWORD

Some may say, "What! Another book about Charleston!" But those of us on both sides of the Atlantic who have become captivated by her personality will warmly welcome it. For her centuries of history have given her distinctive character, and the beauty of her architecture lends endless charm. These combine to form a style and indeed personality that must be unique.

Most eighteenth-century and many early nineteenth-century homes in European cities are typified by the cool, classical, and disciplined formality of brick or stone crescents and terraces. In North Europe, a building form, which originated in the full glare of a hot Mediterranean sun, was skillfully adapted to the alien and more subdued lighting of a colder and damper climate.

In Charleston, one feels that Georgian architecture has met the climatic conditions that gave birth to its Greek and Roman parentage. The result, however, has not been a mere reversion to the original, but rather an adaptation. House plans have become less formal and more varied. The detailing of cornices, columns, and capitals are freer than one is accustomed to find in Europe. Gardens and yards, too, have gained a closer relationship to the buildings they serve than is usual in colder climates. The unique character of the porches and balconies are a feature of Charleston architecture and act as a natural link between these screened external areas, often behind beautiful wrought iron gates, and the exquisite interiors that characterize so many of the houses.

The local custom in providing building land combined with the sense of independence of a vigorous yet cultured population has produced an unusual variety in what are often detached or semi-detached houses. Good taste and a certain gaiety have, however, ensured that they respect and complement one another and, so, have produced whole streets of such unusual charm.

Fires and bombardments in the past have failed utterly to destroy the personality of Charleston. Perhaps they have actually enhanced it by increasing the age-span of essentially classical houses in these streets. One feels that where homes have been destroyed they have been lovingly replaced, in character if not in the same period style, by their proud and undefeated owners.

Certainly it is a characteristic of Charlestonians to cherish the historic parts of their city, and the well-chosen and fascinating collection of photographs in this book will, one knows, give great pleasure to all.

It is a great privilege for any member of my profession to be invited to write a preface for this book and my enthusiasm for Charleston will, I hope, compensate in some measure for my temerity in doing so after only one visit.

BART, I.S.O., R.I.B.A.

LIST OF PHOTOGRAPHS

CHARLESTON THEN
The 1890s

The photographer who arrived in Charleston one winter day during the 1890s had a specific mission—to locate and photograph places of interest in and near Charleston. Traveling by horse and buggy he toured the city, photographing houses and hotels, railyards and rooftops, mills and monuments, from Ashley to Cooper, from Battery to Wragg Mall. And beyond, from Fort Moultrie to Drayton Hall, and north to Summerville's Tea Farm.

The mood of Charleston's people, which his pictures seem to reflect, is one of relaxing from the turbulent period of the city's recent past—from fire, war, and earthquake. Time for a stroll on the Battery, or to the Clyde Line wharf for a look at the new steamers now rapidly replacing the old sailing vessels. Time for a chat with friends over the newly-installed telephone system. Time to watch a Friday afternoon parade of Citadel cadets on Marion Square or Porter boys at the old Arsenal. Time, if you were quite young, for a goat cart ride. Who knows? Perhaps riding in the next cart was a boy who would later become immortalized as Porgy.

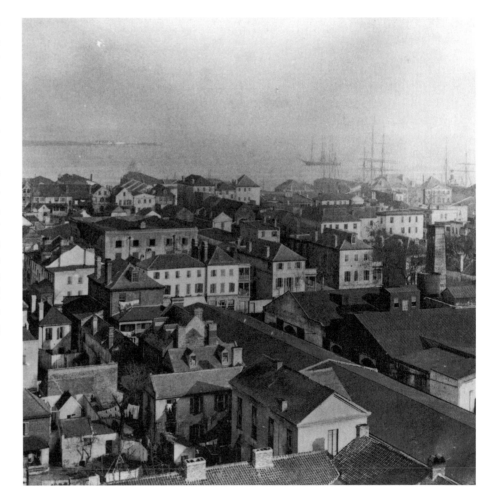

CHARLESTON NOW
The 1990s

The charm of Charleston is perhaps even more evident today than it was a hundred years ago when the traveling photographer made his pictures. Charleston artist and author Elizabeth O'Neill Verner aptly noted that the city had been "mellowed by time."

Certainly a comparison of old and new photographs herein confirms its ability to make time a friend. Even so great a misfortune as the 1989 hurricane that devastated the Charleston area proved only a temporary challenge. The city swept away the debris, repaired the damage, and has become more beautiful than ever. The current photographs by Bob Rhett show a city lovingly cared for and complement his father's pictures taken for the first edition two decades ago.

There are instances, sadly, where notable structures shown in the old photographs are missing from today's view. To prevent further loss of such valuable buildings organizations led by the Preservation Society of Charleston have formed during the past seventy-five years. They have made a remarkable record of protecting, preserving, and restoring the city's venerable structures.

Charleston is moving forward in many other ways. Inviting parks have been established along its waterfront and scenic bridges built over its wide rivers, and city boundaries have leaped their peninsular confinement. Cargo ships and cruise liners frequent the harbor. Major changes are being planned at the site of the Naval Base as that area redefines itself as part of the Navy's downsizing. Spoleto USA, an international arts festival, has become an annual event. And the BOC, an around-the-world solo sailboat race drawing entries from five continents, recently began and ended at this historic city by the sea.

As Charleston prepares to enter the twenty-first century it shows abundant promise of continuing to treasure and preserve its unique architectural heritage and to move confidently into the new millennium as one of America's vital, living port cities.

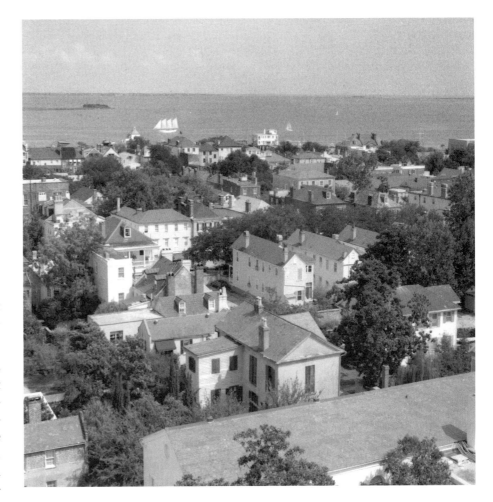

Dedicated with appreciation

to the memory of

Miss Susan Pringle Frost

founder of The Preservation Society of Charleston

seventy-five years ago

and with affection

to the memory of

our great-grandparents

The Reverend Hugh Peronneau Dawes Hay

and his wife

Mary Jane Pinckney

who knew the streets

and sailed the waters

of this city by the sea.

Charleston
Then and Now

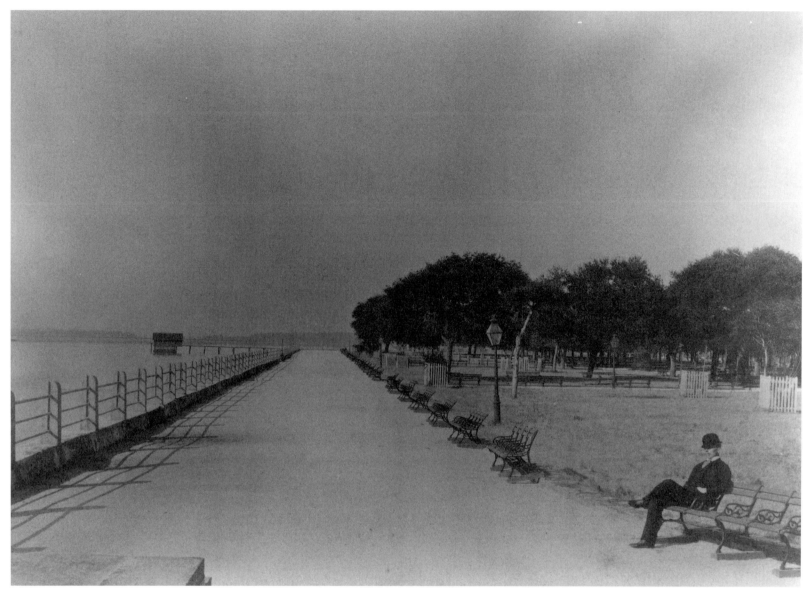

1890s — 1

The Battery viewed in the 1890s from the southeastern tip of the Charleston peninsula, was limited to the south and east borders of White Point Garden, a park whose name derives from the bank of oyster shells on which it was built. It was near here in 1718 that a pirate leader and twenty of his crew were publicly hanged, and buried in the marshes; Stede Bonnet, it is said, was a "gentleman pirate" who took to the high seas to avoid a nagging wife. A monument com-memorating the event is located nearby and mentions Col. William Rhett who was responsible for the capture and from whom one of the authors is descended. With the construction of the seawall and promenade in 1838, the Battery had become a quiet, sunny spot to walk or sit and look out to sea. The wharf and bathhouse in the distance were used by local residents for swimming and boating. On the horizon is the wooded shore of James Island, named for James, Duke of York.

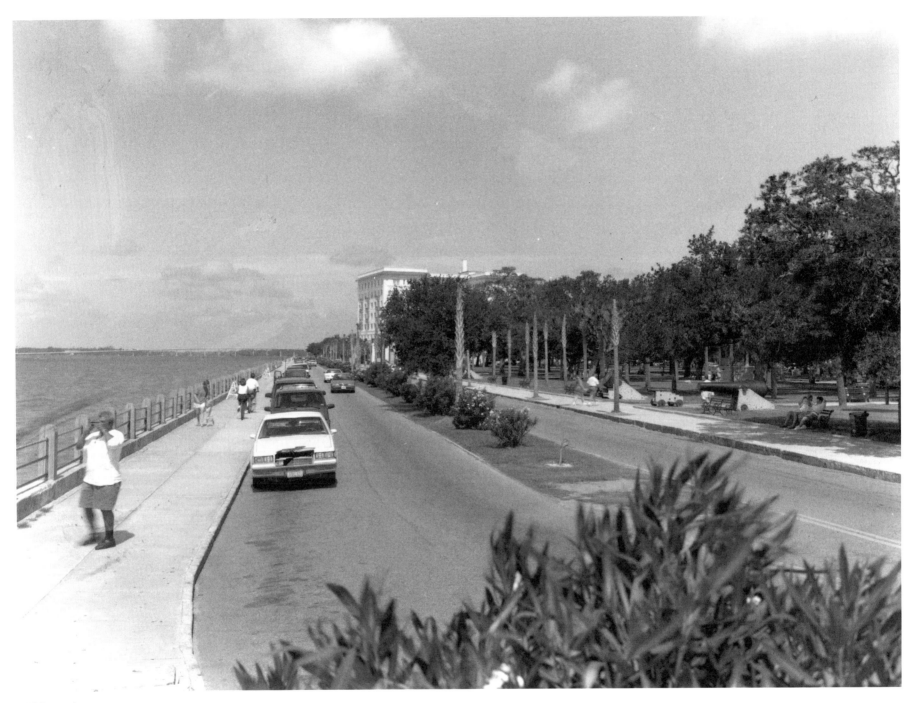

1990s — 1

Charleston's Battery continues to attract visitors in the 1990s, their dress increasingly casual. They view the harbor, feed the seagulls, or perhaps just relax and enjoy the breeze. We note that the pier in front of Fort Sumter House is gone. Tall palmettos now line the boulevard and on the horizon can be seen the new Scarborough bridge directly linking peninsular Charleston to James Island. This welcomed addition provides easy access to the sea islands and a charming view of the harbor area.

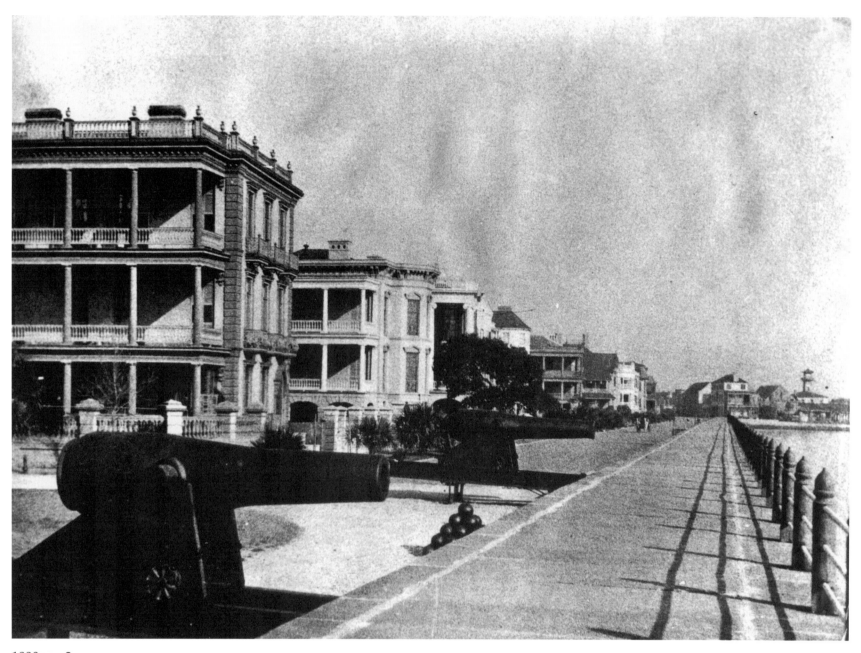

1890s — 2

Guns that defended Charleston in the 1860s point their muzzles harborward from the defilade of High Battery in symbolic defense of the city. The cannon at right was salvaged from the sands of Sullivans Island where it had lain since the close of the Civil War. Most of the houses seen in this view were about fifty years old when this picture was made. An early Victorian influence is evident in the house next to the corner, built some twelve years after its Greek-Revival neighbor to the north.

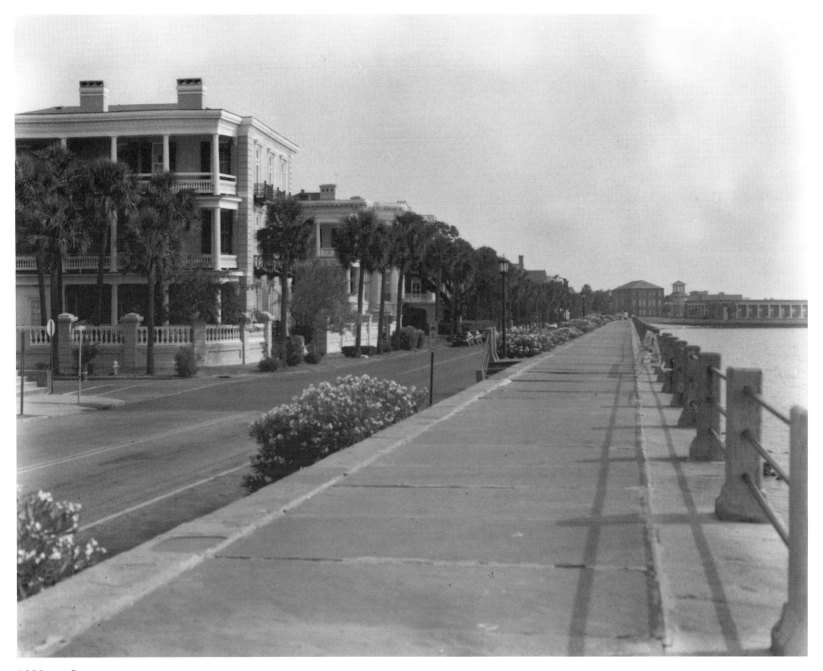

1990s — 2

The span of a century now separates these old and new views of High Battery. Yet the handsome houses that look seaward over one of America's most historic harbors remain basically unchanged. On the street before them, however, a revolution has occurred in the mode of transportation.

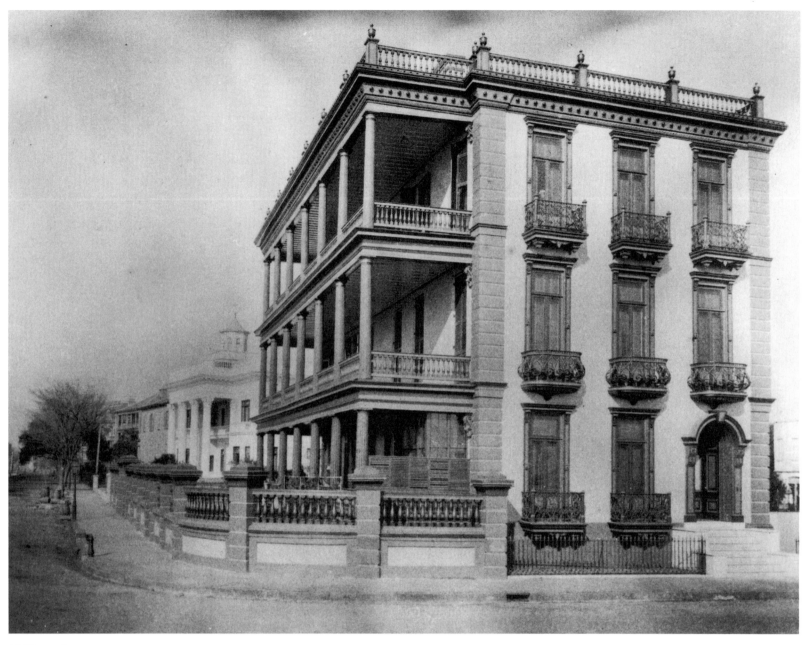

1890s — 3

No. 1 East Battery was selected by Lewis deSaussure in the early 1850s as the site for his home. One can imagine an excited gathering on the widow's walk, with its unsurpassed view of the harbor, that day in 1861 when Fort Sumter was fired upon. A few years later the city came under bombardment from Federal guns across the harbor and, when a shell burst in their yard, the deSaussures reluctantly decided to leave.

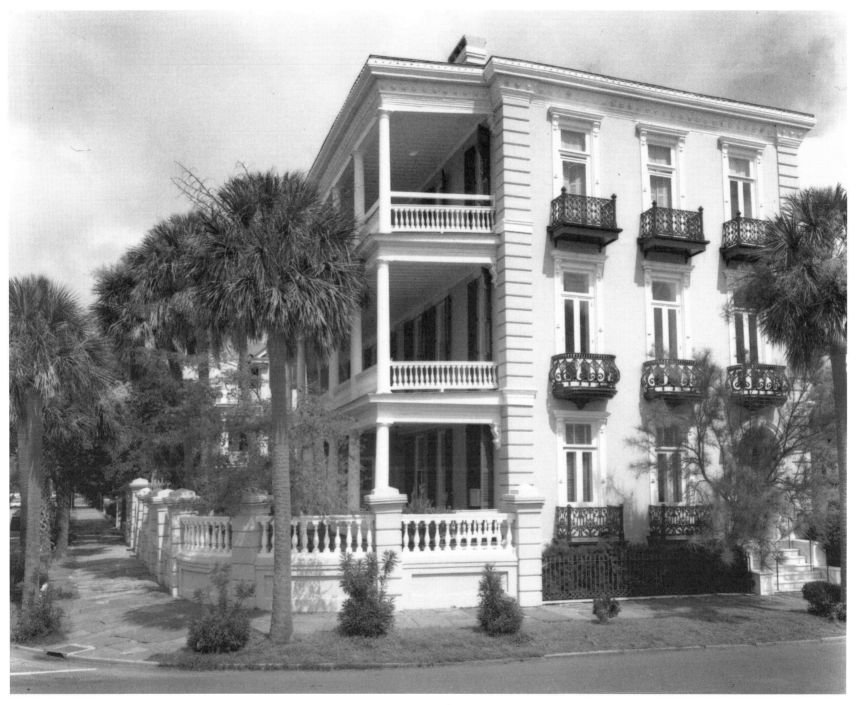

1990s — 3

The deSaussure House retains its generous piazzas and iron balconies to provide present owners a beautiful view of river and harbor. Gone, however, is the roof balustrade of the widow's walk.

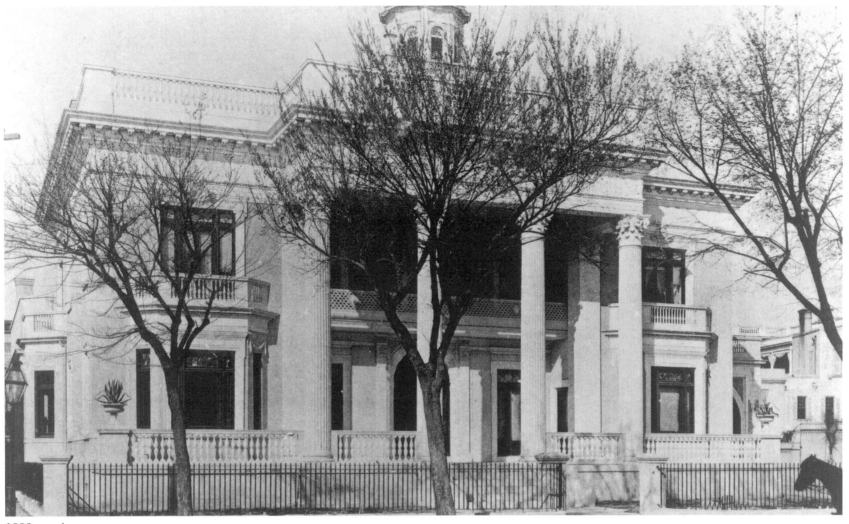

1890s — 4

The elegant home of Andrew Simonds had only recently been completed when this photograph was made. It can be seen also in the previous photograph. Not typical of Charleston residential architecture, it nevertheless fits into the city's pattern of accommodating varied styles in harmony side by side.

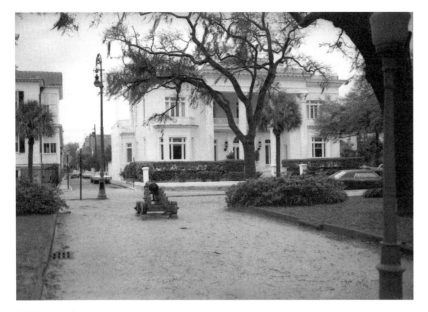

Known as the Villa Margherita, the building was operated for many years as an inn catering to wealthy visitors. The guest list included such well-known people as Eleanor Roosevelt, Henry Ford, and Alexander Graham Bell.

1970s — 4

Once again a private residence, this stately house at 4 South Battery continues to keep harmonious company with its older neighbors. The small cannon, however, which pointed north up Church Street in the 1970s photo, now faces south towards James Island from the opposite end of the White Point walkway.

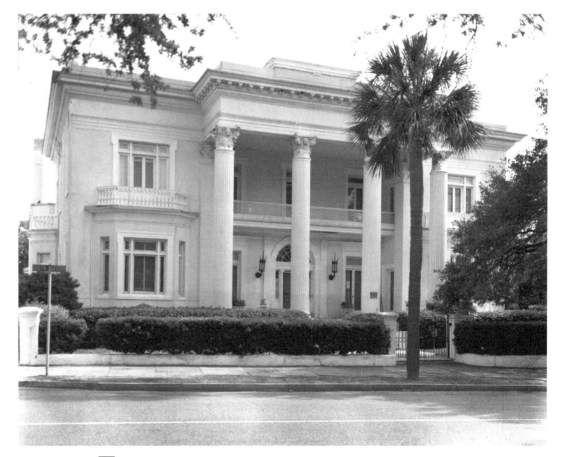

1990s — 4

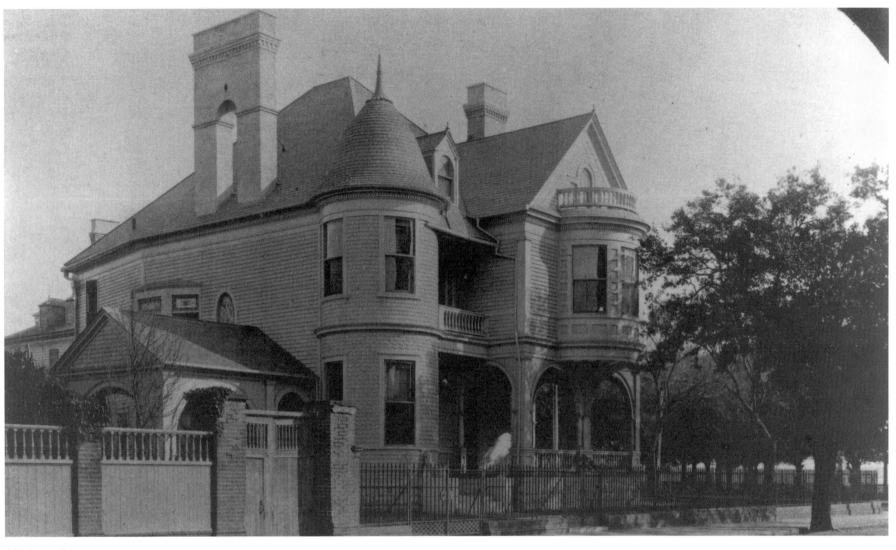

1890s — 5

One block west on South Battery at the corner of Meeting Street is a Victorian home, residence of Waring P. Carrington at the time of this photograph. No doubt its occupants were often entertained by music from the bandstand in adjacent White Point Garden.

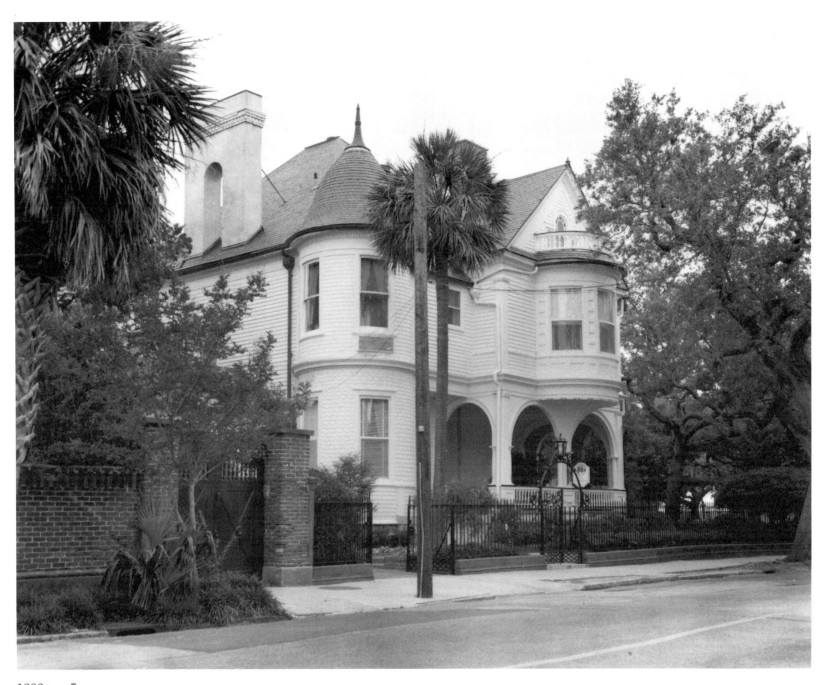

Number 2 Meeting Street, now a popular inn, was a recent witness to a White Point Garden gathering at which the Preservation Society of Charleston celebrated its 75th birthday. In comparing the two photos it can be noted that the distinctive double chimney has been significantly altered as a result of recent hurricane damage.

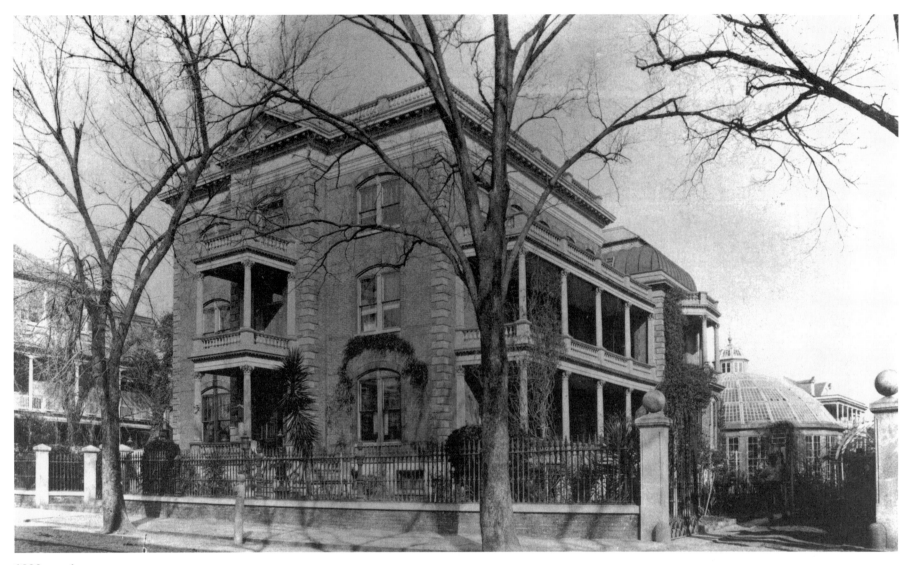

1890s — 6

This handsome brick dwelling on lower Meeting Street was the home of George W. Williams, Sr., when this picture was made. Like the deSaussure House and the Villa, it was topped with a balustrade.

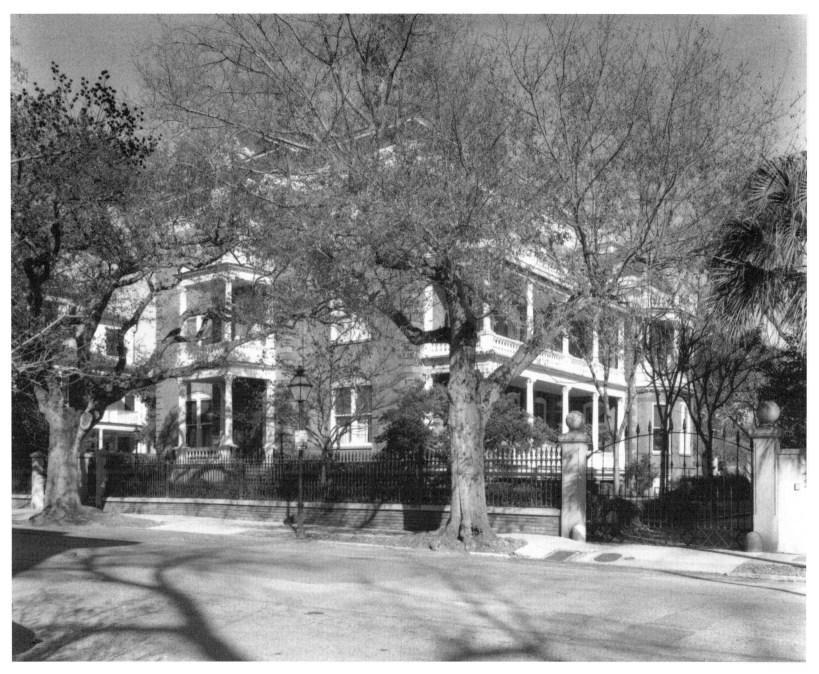

1990s — 6

The Calhoun Mansion at 16 Meeting Street was one of the few expensive houses built in Charleston just after the War Between the States. The house is now open for tours.

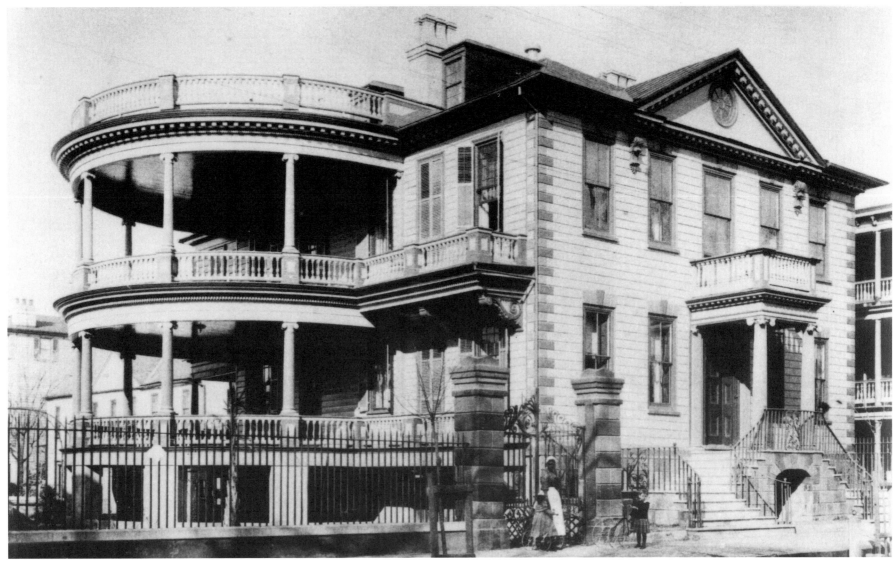

1890s — 7

The John Edwards House at 15 Meeting Street was built about 1770. George W. Williams, Jr., who lived here at the time of this photograph, is said to have added the spacious piazzas to provide shelter in case of rain during the annual ice cream party he gave for orphans.

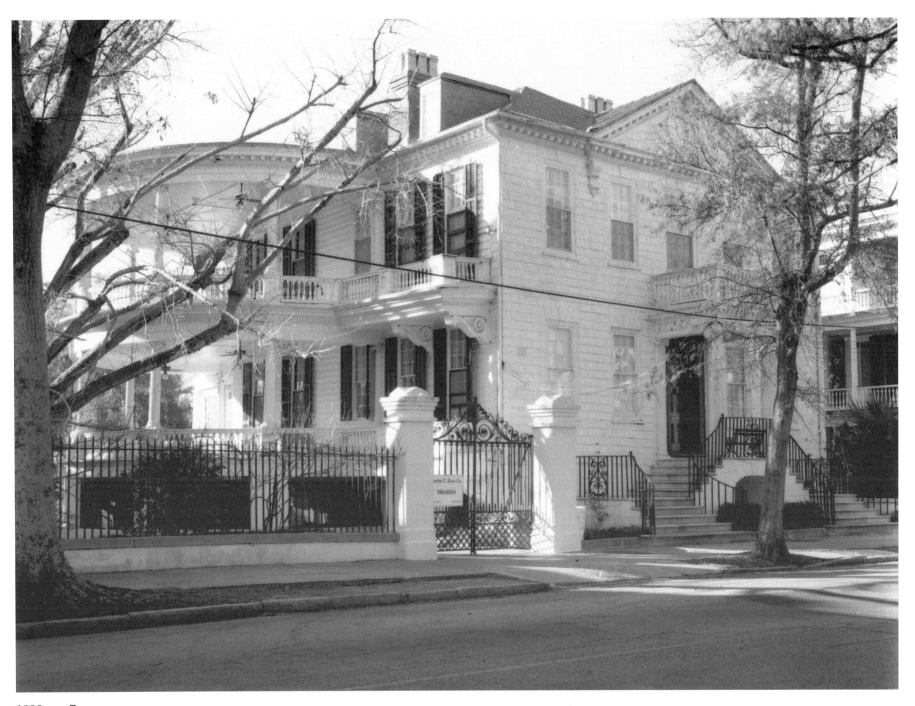

Sunlight reflected from the cypress blocks with which 15 Meeting Street is surfaced suggest a marble exterior—which is the effect its builders are said to have sought.

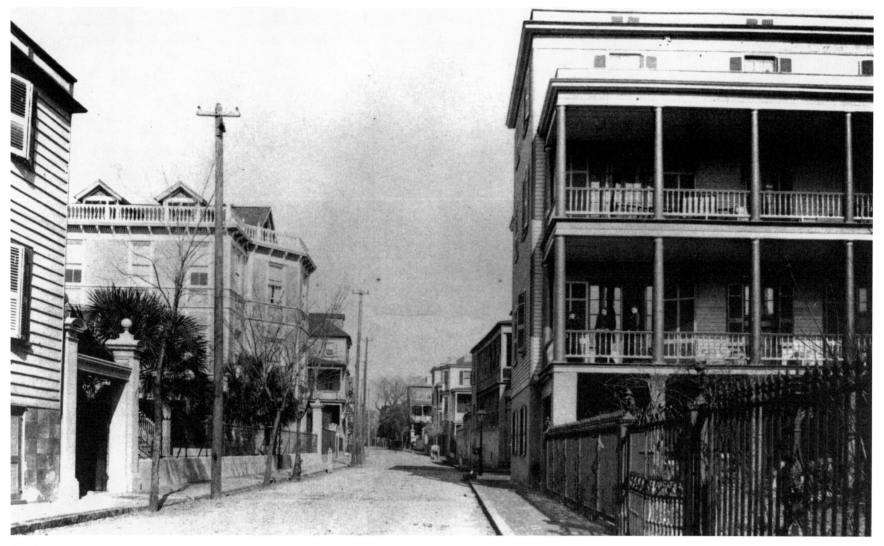

1890s — 8

View from the south end of Legare Street, named for Solomon Legare, a wealthy Huguenot merchant—These ladies have gathered on their second-floor piazzas to watch the photographer at work. Charleston's piazzas, perhaps the most typical feature of the city's residential architecture, have been popular since the mid-1700s, and wherever possible face south to catch the sea breeze. Their origin has been speculated to be France or the West Indies but as yet remains a mystery. Down the street, adjacent to the curb, can be seen two protective fences enclosing small trees—an investment in future shade.

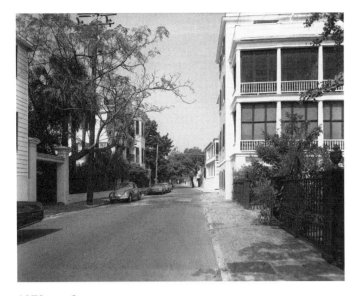

Substantial changes have occurred in this section of Legare Street, one of Charleston's most prized addresses, since the 1970s. No. 5 Legare, its white front partially obscured by palmettos in the 1990s photograph, can be seen to have a bowed front in the earlier pictures. The house at right is currently being renovated and the entire area reflects continuing attention from owners.

1970s — 8

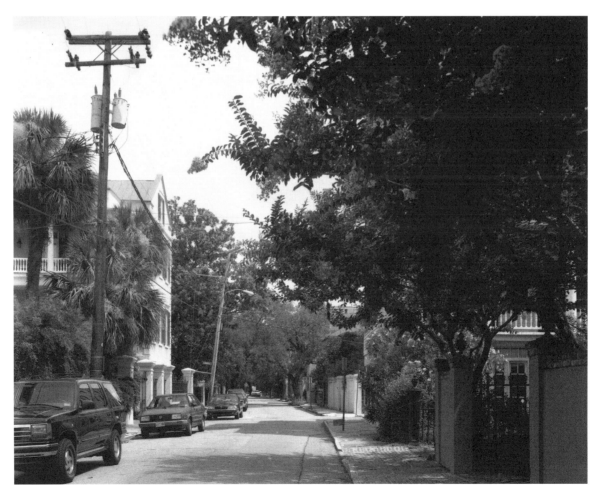

1990s — 8

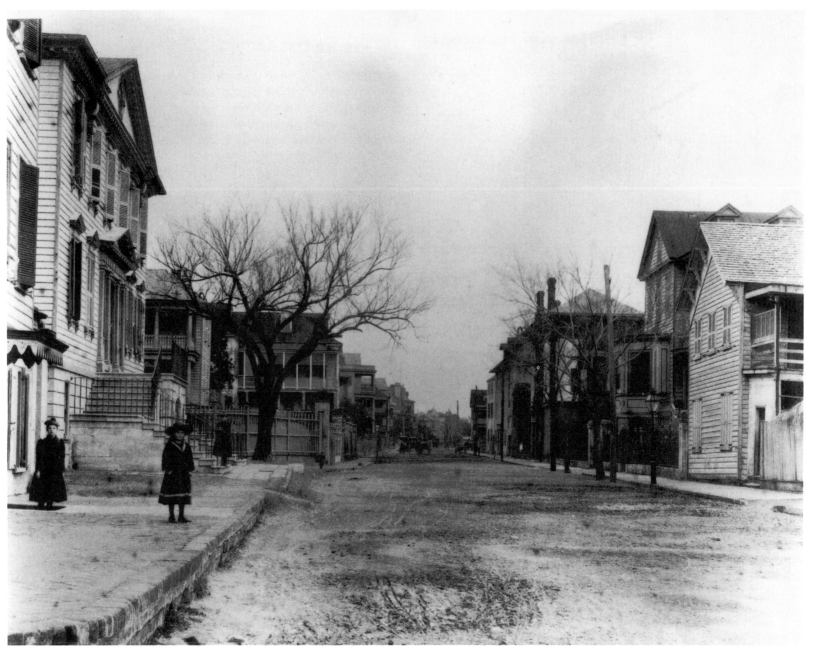

1890s — 9

View on South Battery—The young girls posing in front of the William Gibbes House had been told to stand very still, since the photograph required several seconds of exposure. Gibbes, a merchant and planter, built this handsome Georgian dwelling about 1772. Across the street he had constructed a wharf, through the marsh to the Ashley River, which served for boating, fishing, and bathing.

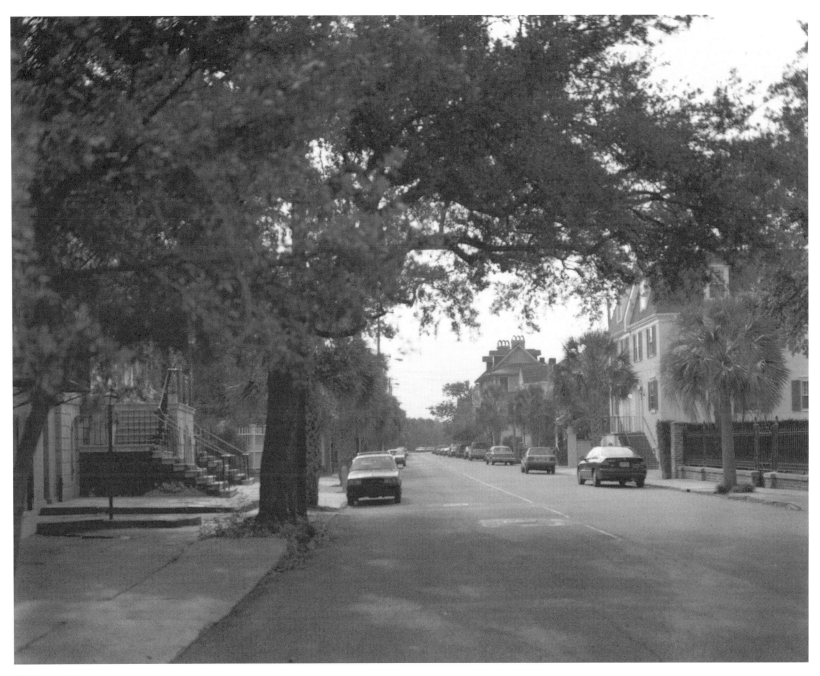

1990s — 9

While tree foliage obscures much of the Gibbes House in this photograph, the handsome homes along South Battery continue to offer places for gracious living as Charleston nears a new millenium.

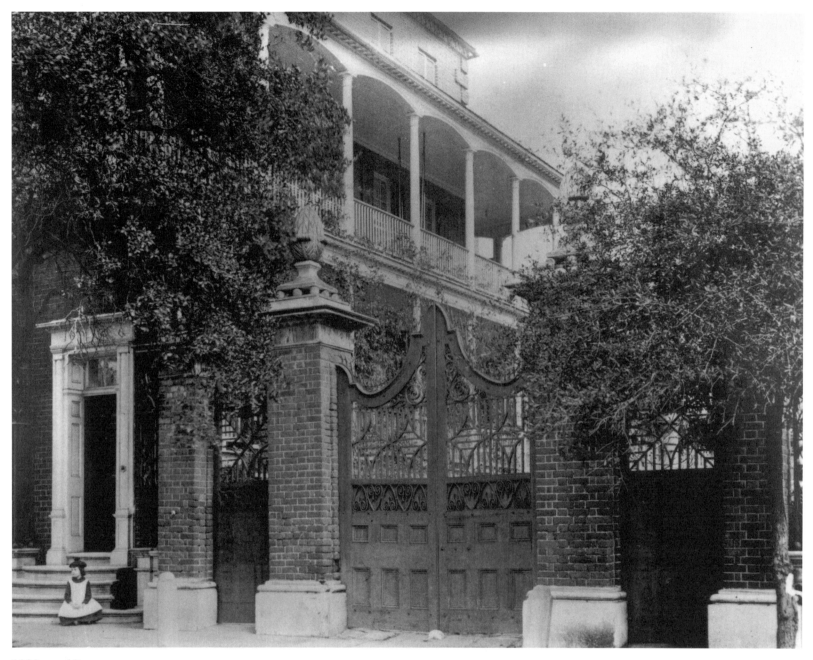

1890s — 10

House and gateway at 14 Legare Street—The little girl sitting demurely above is occupying the marble steps of a house already one hundred years old when this photograph was taken. Built by Francis Simmons, a planter, it was later the home of George Edwards, who added the handsome gateway and fencing. It is said that a third-floor duel took place between a man in this house and one in the house across the street, resulting in the death of the former.

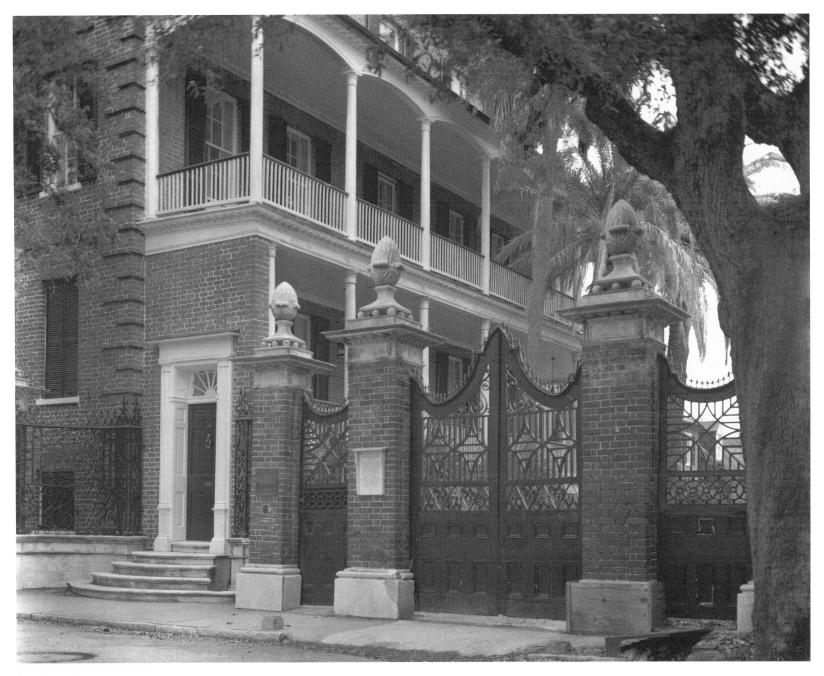

If a charming young girl in 1890s attire were seated on the entrance steps of 14 Legare Street there would be little at this site to indicate the passage of a century.

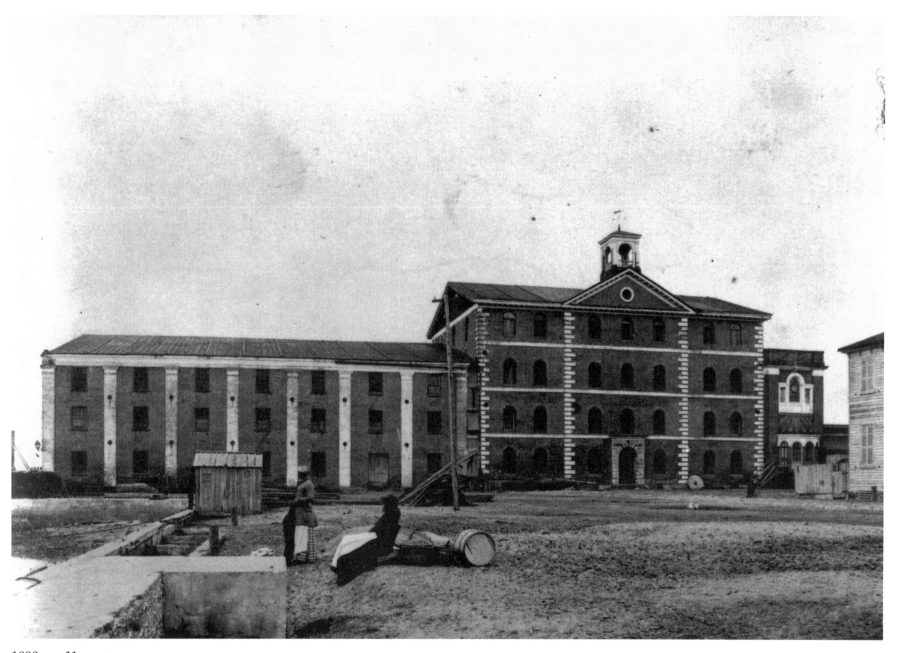

1890s — 11

The old Chisolm Rice Mill, built in 1830, was located beside the Ashley River at the foot of Tradd Street, its architecture typical of other Charleston rice mills. The first rice planted in America was sent to Charleston by the Lords Proprietors in 1672. Husking of rice to remove the tenacious chaff was very primitive until Jonathan Lucas of Charleston shortly after the Revolution developed the first successful rice mill. Rice then became the major crop of coastal Carolina.

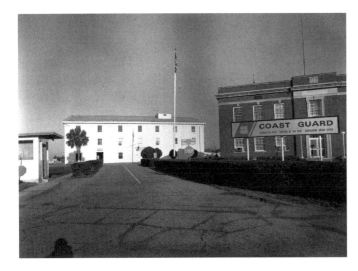

The Coast Guard operates a base at this site. Changes at the facility during the past twenty years include relocation of the flag pole, installation of a new fence, and replacement of the sign. The base continues as an attractive and functional place that still utilizes the 160-year-old building it inherited from the Chisolm Rice Mill.

1970s — 11

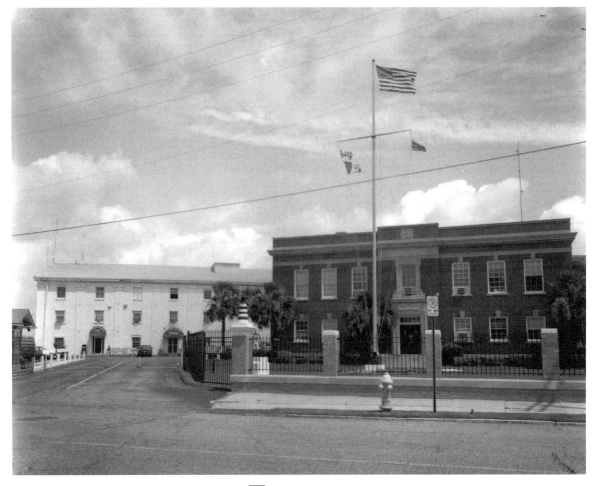

1990s — 11

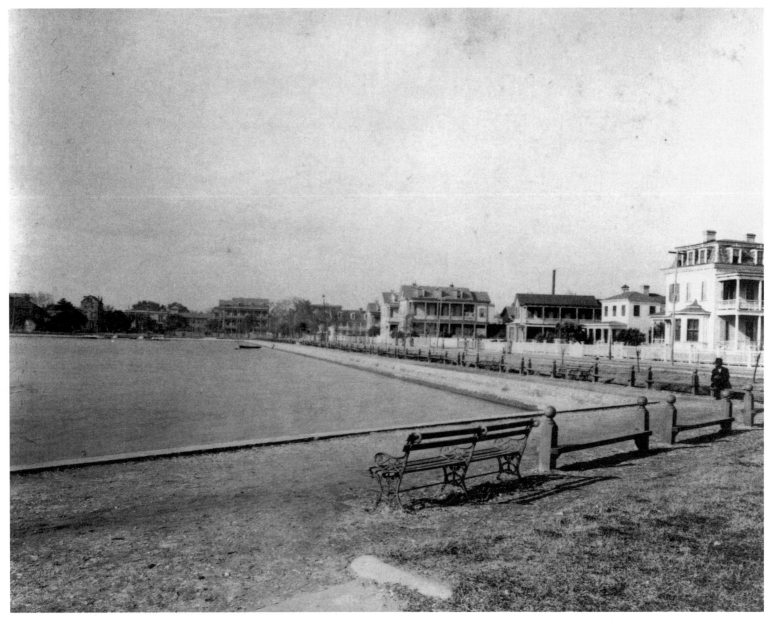

1890s — 12

West End Lake was originally a pond opening into the Ashley River. Through the years it was improved and by the 1890s had become a popular place for boating and recreation. The cast iron and slat benches appear to be recent additions supplementing those of single wooden beam design.

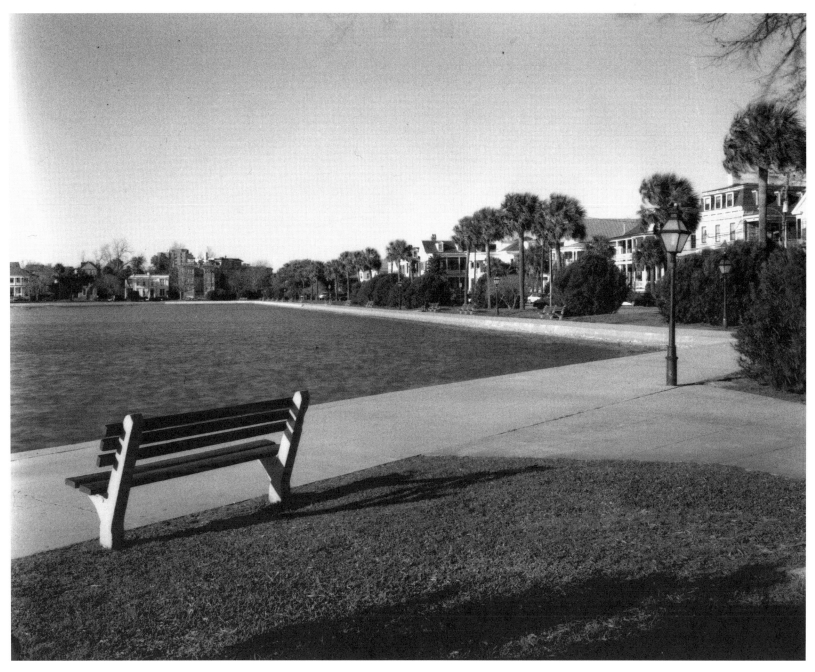

1990s — 12

The tranquil waters of Colonial Lake, as it is called today, belie the scene of a few years ago when the might of Hurricane Hugo passed over the city.

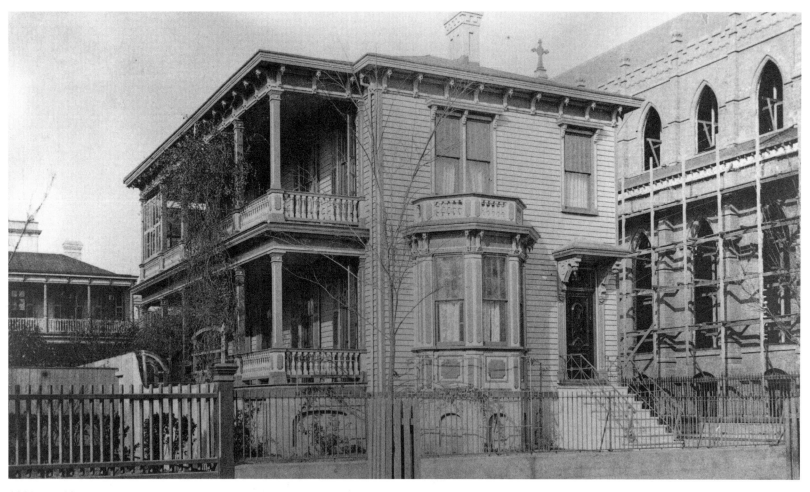

1890s — 13

The Broad Street residence of John Tiedeman—Under construction on the opposite corner of Legare Street is the Catholic Cathedral of St. John the Baptist. Built without nails, it replaced an earlier cathedral that burned during the great fire of 1861. It is said that the fire insurance on the old cathedral had lapsed a few days before, probably because of war-caused disruption of commerce between North and South. Thus, rebuilding was delayed.

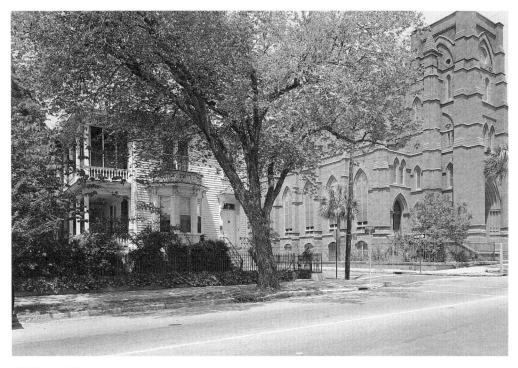

Today, garden shrubbery and ornamental trees grace this well-maintained former residence of John Tiedeman. Across the street, the Cathedral has mellowed into its surroundings and become a familiar Charleston landmark.

1970s — 13

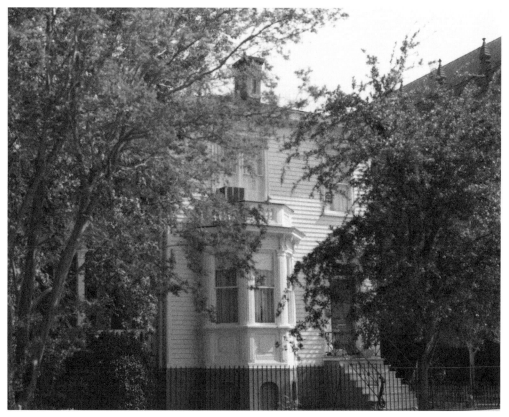

1990s — 13

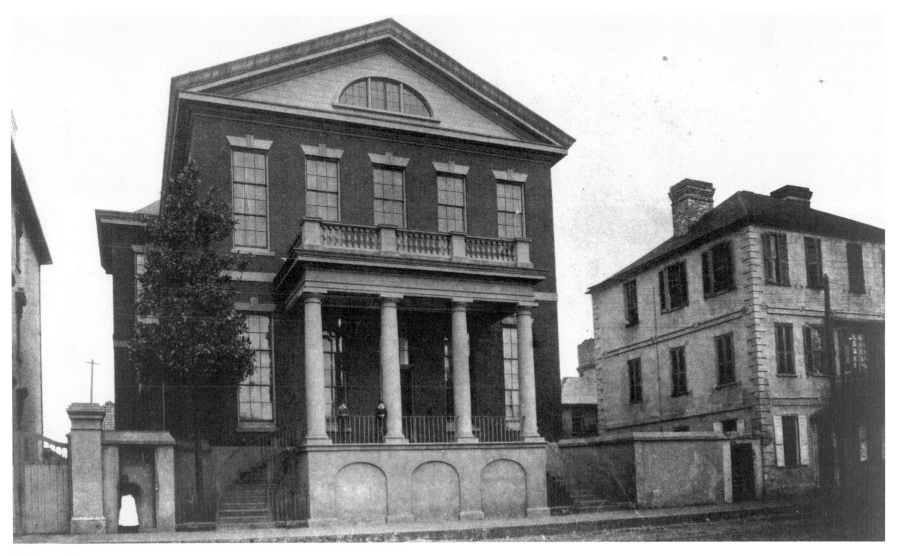

1890s — 14

Colonel Thomas Pinckney House (The Bellinger House) at 114 Broad Street, begun about 1790, was the residence of Bishop Northrup when this photograph was taken. Two well-dressed boys watch the cameraman from the portico, while a woman in typical white apron poses in the gateway. The early Georgian residence on the right was built before 1728 by William Harvey. In 1750 it was leased to James Glenn, Royal Governor of South Carolina. Governor Glenn, a Scot, was noted for his just and successful dealings with the Indians. His contemporary portrait was recently discovered to be at Breckin Castle on the northeast coast of Scotland, the property of the Earl of Dalhousie. Ambassador and Mrs. Joel Poinsett, for whom the flower poinsettia was named, were later owners of this house. At the time of the photograph it belonged to the King family.

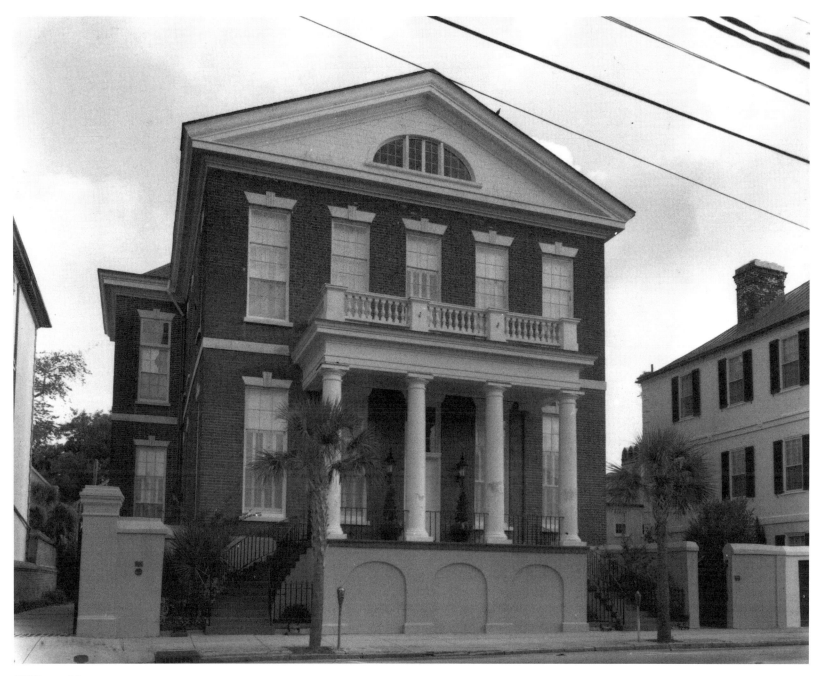

1990s — 14

The handsome magnolia tree of the earlier photograph is gone while twin palmettos now stand guard at the sidewalk adjacent to the Colonel Thomas Pinckney House. Both this valuable building and the one to the right seem in even better condition than a hundred years earlier.

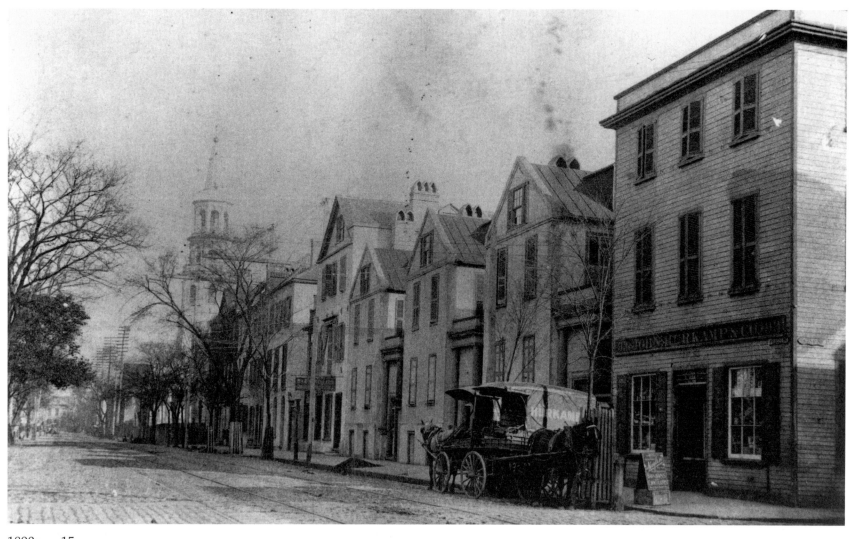

1890s — 15

Broad Street viewed from King—The sidewalk sign in front of John Hurkamp's corner store advertises bon-bons and chocolates. His two wagons are parked to permit loading from the sidewalk, while the horses are turned ninety degrees to avoid extending over the trolley tracks. Further down the brick-paved street can be seen Saint Michael's steeple, and dimly visible at the foot of Broad is the old Exchange Building, where President George Washington was officially received during his visit to Charleston in 1791.

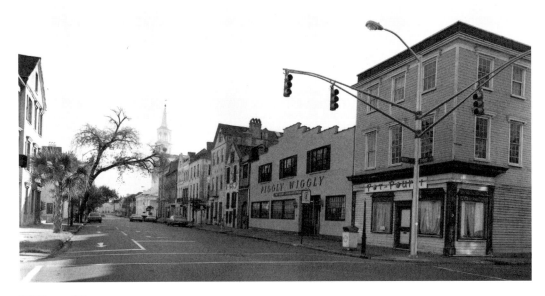

The familiar profile of Broad Street, which was the central street in the old walled city of Charles Town, has been softened since the 1970s by the addition of numerous palmetto trees along the sidewalks. And traffic is directed by less flamboyant signals as the attractiveness of the city continues to improve.

1970s — 15

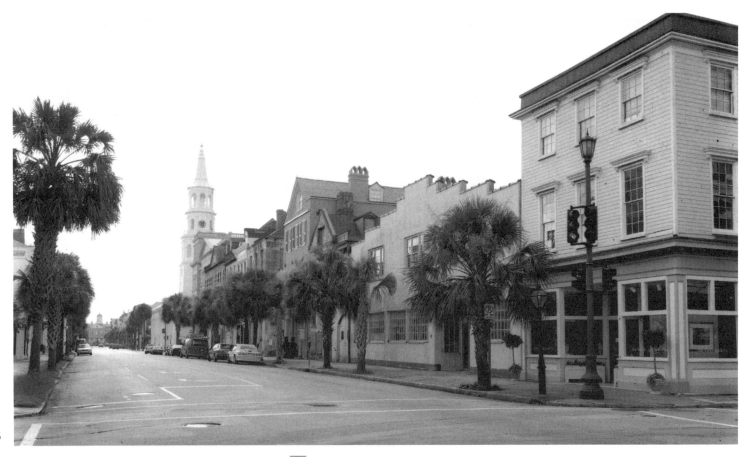

1990s — 15

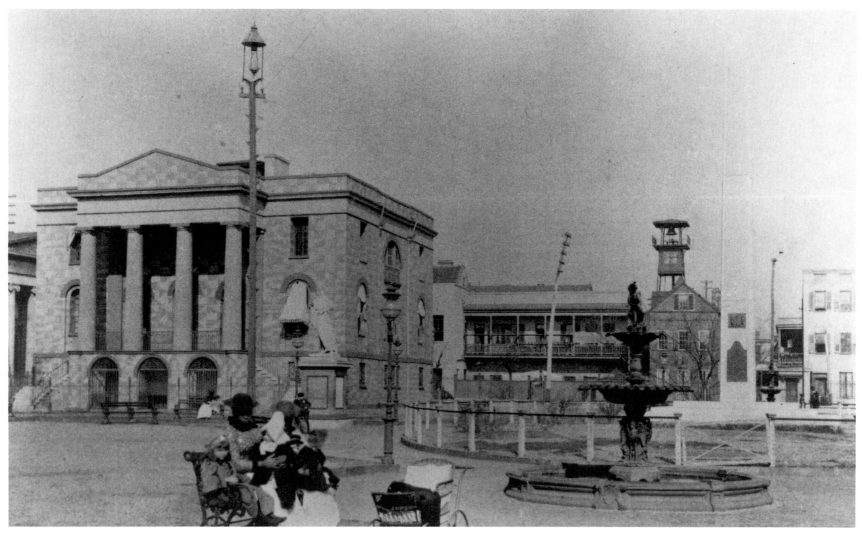

1890s — 16

Washington Park during the 1890s was a pleasant spot to sit in the winter sunshine, as these nurses and their young charges have discovered. The Doric-style Fireproof Building at left, situated on the corner of Meeting and Chalmers Streets, was designed by Robert Mills, famed designer of the Washington Monument. Records indicate that only stone, brick, and iron were used in its construction, begun in 1822. Behind the fountain, the bell tower of the fire station (an unlikely neighbor for a fireproof building!) is seen above the rooftops. The bell had been in place only five years when this picture was taken. In addition to sounding fire alarms, it was used to warn the city of pending freezes and tropical storms.

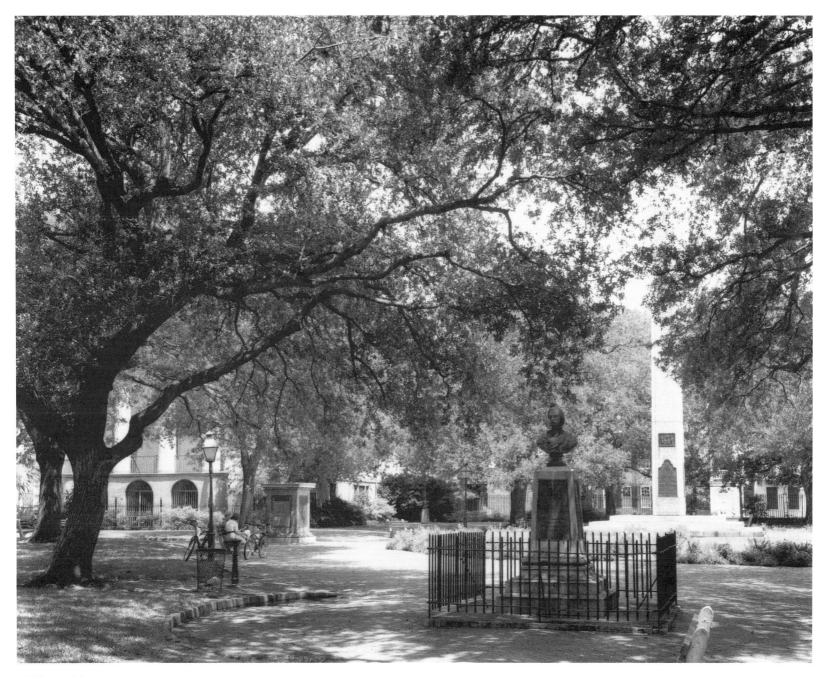

1990s — 16

A century after the gathering of nurses and children in the 1890s photo Washington Park continues to offer moments of rest and quiet. Those who accept it are only a few feet from the busy cor- ner of Broad and Meeting Streets, the old entrance to Charles Town when it was a walled city.

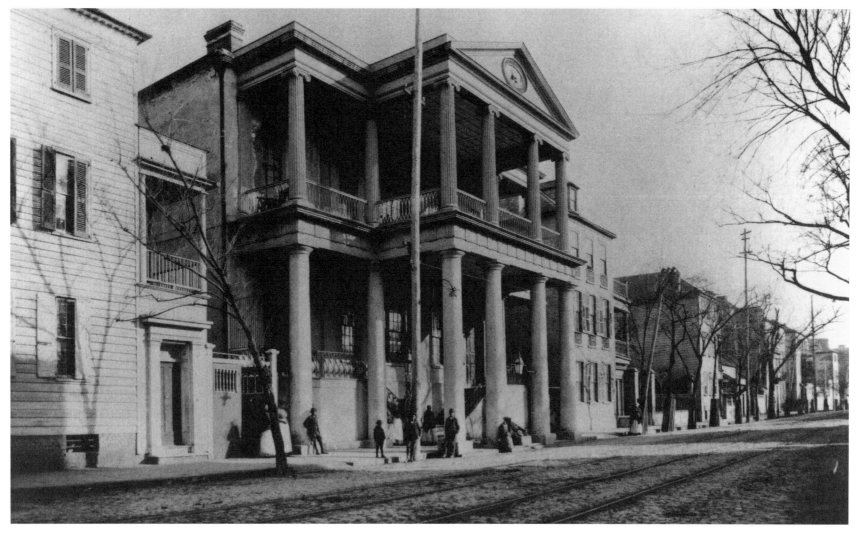

1890s — 17

South Carolina Society Hall at 72 Meeting Street appears to have been a popular gathering place in the 1890s. The Society was organized in 1737 by a group of French Huguenots for charitable purposes. The building, designed by Gabriel Manigault, dates from 1804, while the portico was added in 1825.

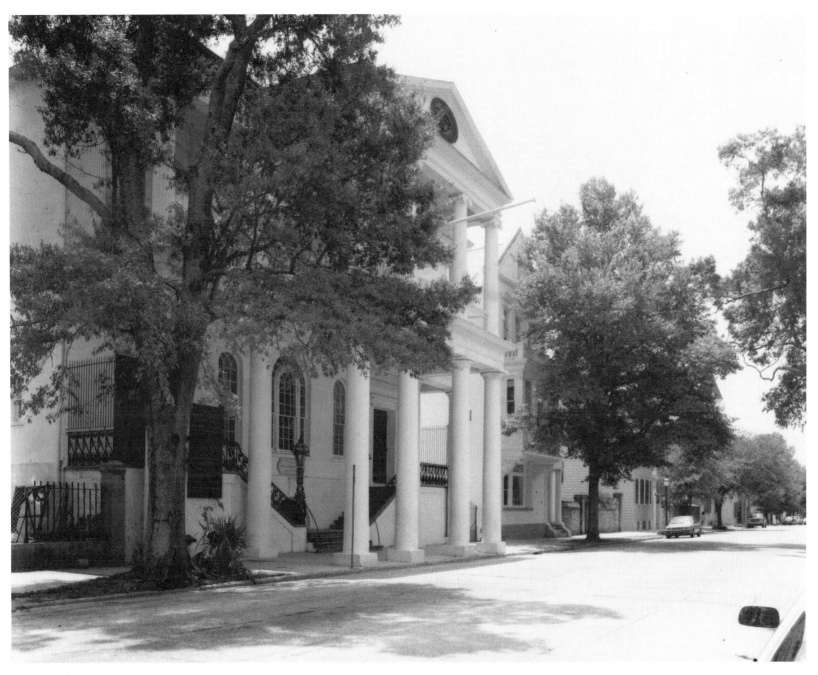

1990s — 17

Extensive improvements have recently been completed on this outstanding building and it approaches the age of two hundred years in excellent condition.

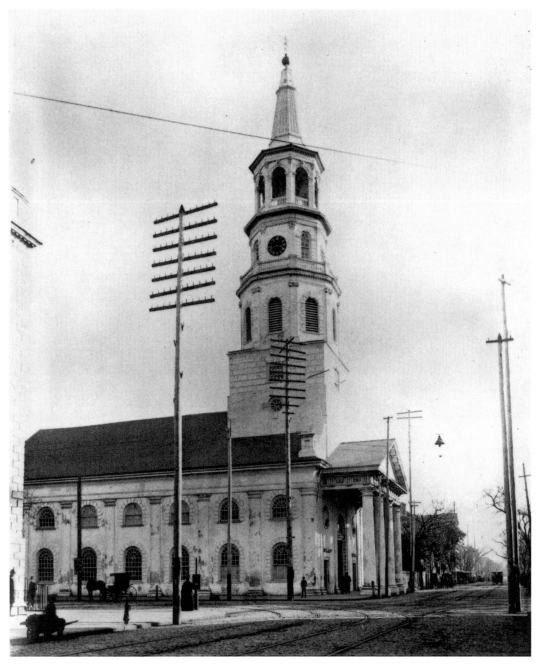

Saint Michael's Church was built between 1752 and 1761, and is the oldest church structure in Charleston. George Washington attended services here during his visit in 1791. For many years, a watchman was stationed in the steeple at night to look for fires, so often the cause of wide devastation throughout the history of the city. Note the trolley car at far right. The intersection of Broad and Meeting Streets shown here was the original gateway to the old walled city of Charles Town, which lay between Meeting Street and the Cooper River. A drawbridge at the "Half-Moon" Battery, which stood here, provided controlled access to the town.

1890s — 18

St. Michael's entered the 1990s encased in steel scaffolding as extensive damage from the hurricane of 1989 was repaired. The church is now fully restored and has recently begun again the centuries-old practice of "changing ringing" its famous bells to produce a variety of tuneful combinations. The streets outside have been freed of utility poles, and this important corner of Charleston is perhaps more beautiful than ever before.

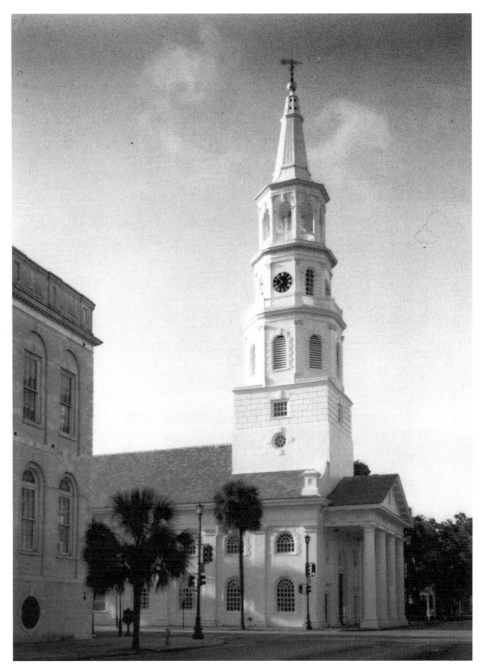

1990s — 18

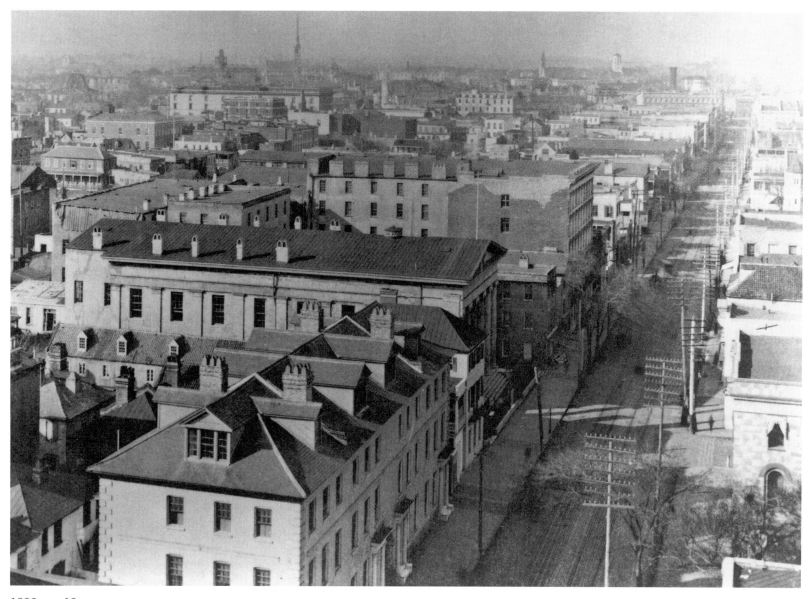

1890s — 19

Charleston viewed from Saint Michael's steeple—Stretched below and running north is Meeting Street, which originally formed the western boundary of the old walled city. Easily identified beyond the Timrod Inn in the left foreground is the columned front of Hibernian Hall. A few doors further north is the Saint John's Hotel, whose famous guests have included General Robert E. Lee and Theodore Roosevelt. Pointing heavenward on the horizon is the steeple of Saint Matthew's Church.

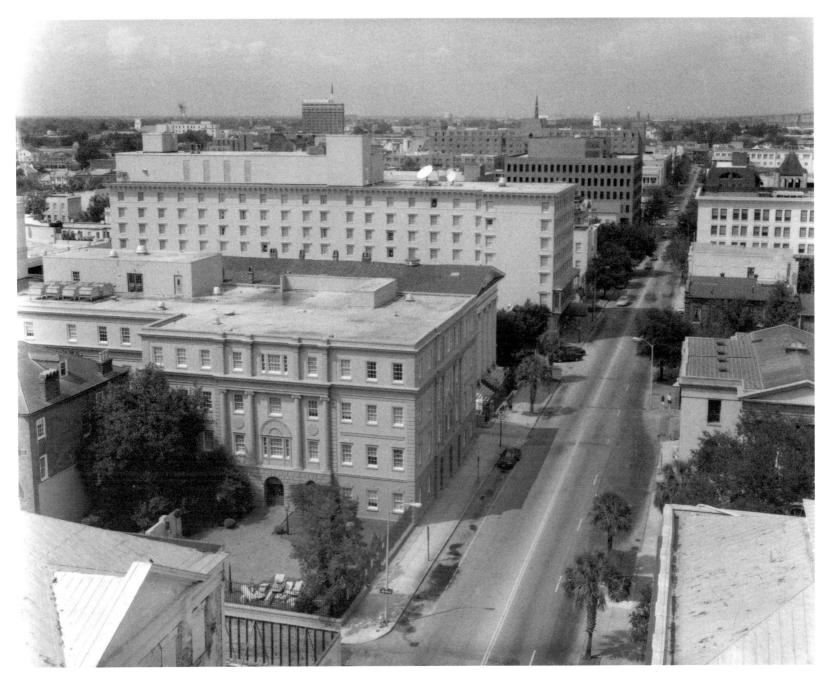

1990s — 19

In the foreground on the left side of Meeting Street, the Hibernian Hall is almost obscured by the county office building, and the old Saint John's Hotel has been replaced by the Mills House, named and architecturally patterned after the original hotel on this site. The Fireproof Building, now home to the South Carolina Historical Society, is in the right foreground. On the horizon at left is the Medical University of South Carolina. Historic Meeting Street seems tranquil on this afternoon.

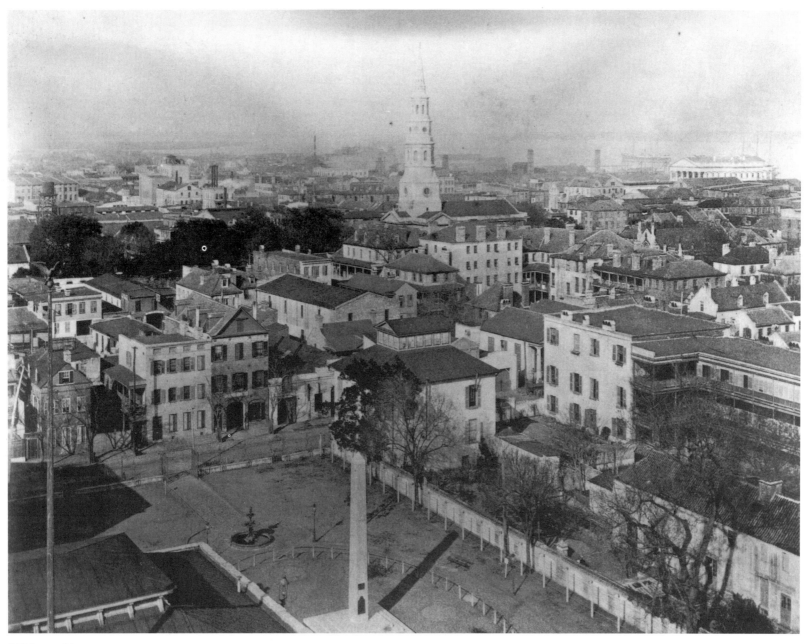

1890s — 20

Saint Philip's Church dominates the skyline above Washington Park in this photograph. Home of the oldest Protestant Episcopal Church congregation in South Carolina, this structure replaced a similar one lost to fire in 1835. The United States Custom House can be seen to its right, while beyond, meandering across the horizon, is the Cooper River.

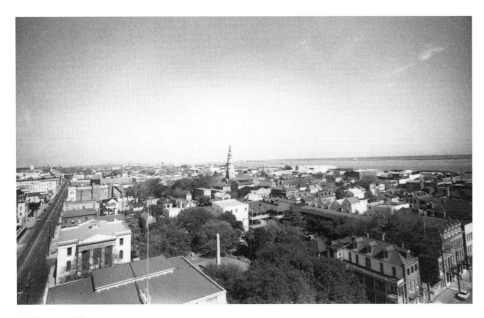

Church steeples continue to control the skies of Charleston. In this case it is Saint Philip's that provides the center view, and St. Michael's through whose kindness the view is provided.

1970s — 20

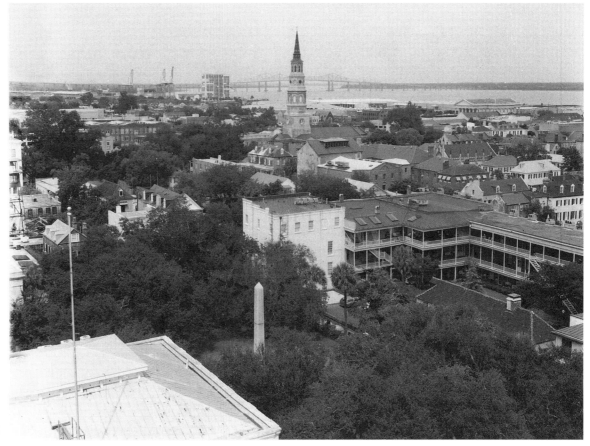

1990s — 20

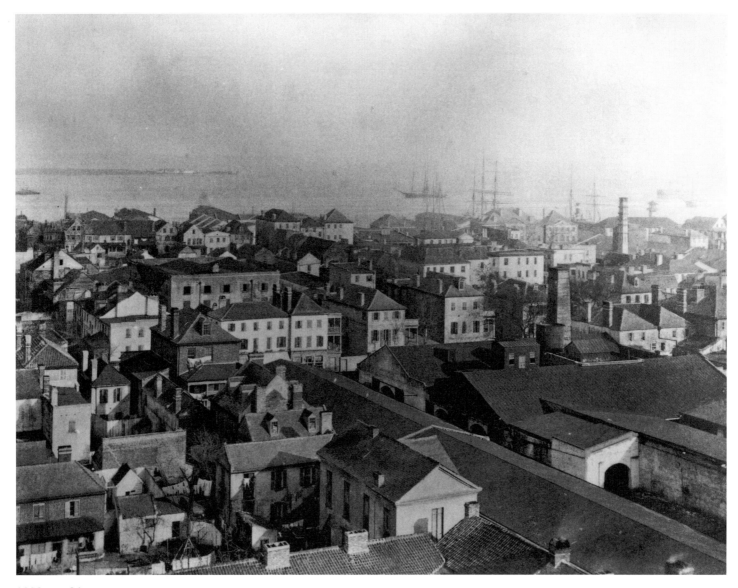

1890s — 21

The rooftops of Charleston form a fascinating mosaic in this southeastward view from Saint Michael's steeple in the 1890s. Tall chimneys and long warehouses intermix with old residences in a random pattern. Beyond the shore, sailing ships lie at anchor in the harbor and at dock on East Bay. Situated on a harbor island at left is Castle Pinckney, a fortification built shortly before the War of 1812 and used as a prison during the Civil War. It was in this harbor that the first submarine to sink an enemy vessel was launched. The Confederate submarine *Hunley*, with a volunteer crew of eight men, torpedoed and sank the Union ship *Housatonic*, which was blockading Charleston, in 1864. However, the effect of the explosion caused the *Hunley* to sink also, with loss of its crew.

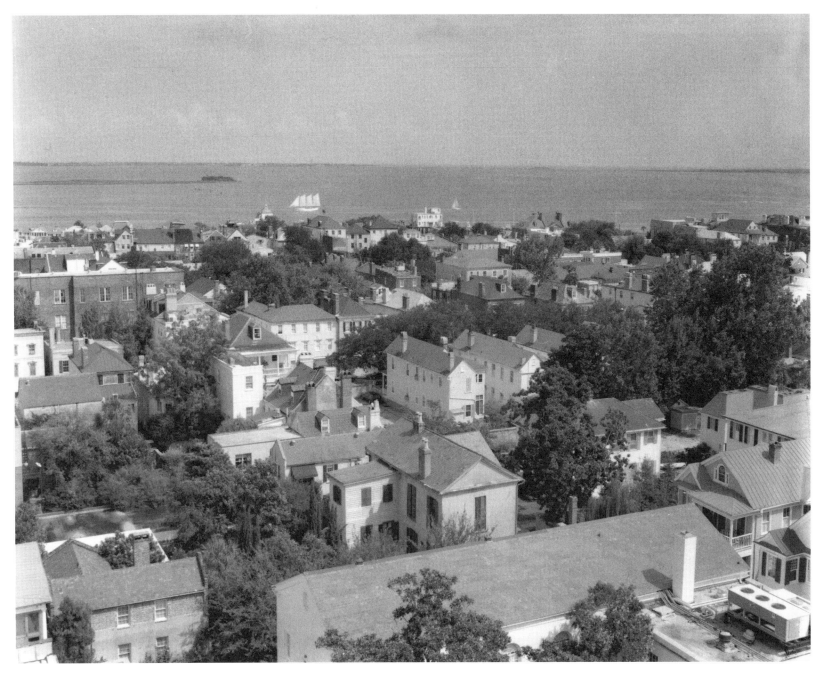

1990s — 21

The schooner *Pride of Charleston* links this view to the companion picture of a century ago in which sailing vessels dominated the harbor. Beyond the harbor entrance the recent discovery of the Confederate submarine *Hunley*, the first underwater vessel to sink an enemy ship, provides yet another tie with the past.

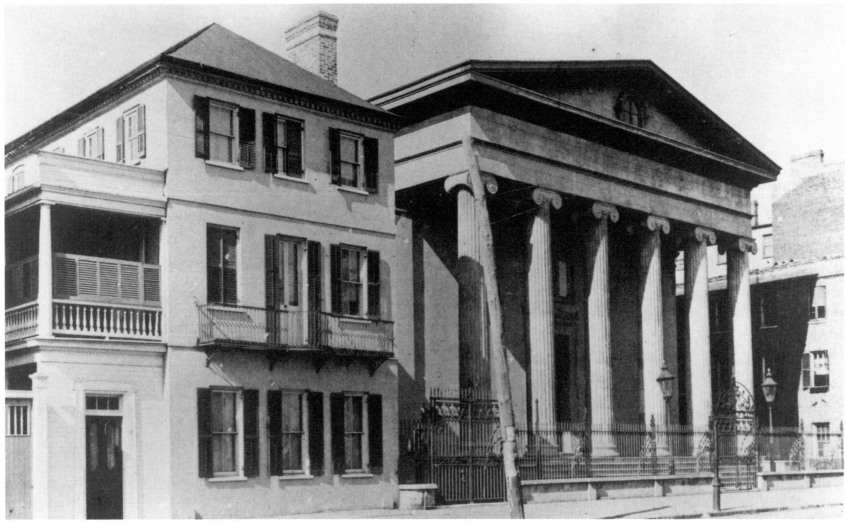

1890s — 22

Hibernian Society Hall was built in the classical Greek style for the Hibernian Society, some fifty years before this picture was taken. The typical three-storied single house (so named for being a single-room wide) has a particularly attractive wrought-iron balcony.

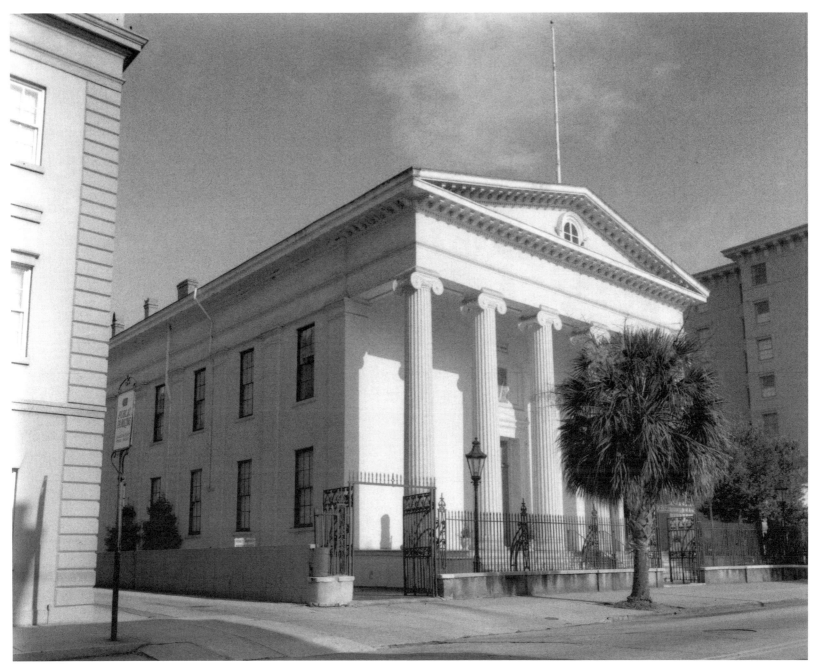

The Hibernian Hall, nestled between the O. T. Wallace county office building and the Mills House Hotel, continues to offer a handsome setting for holding special social functions.

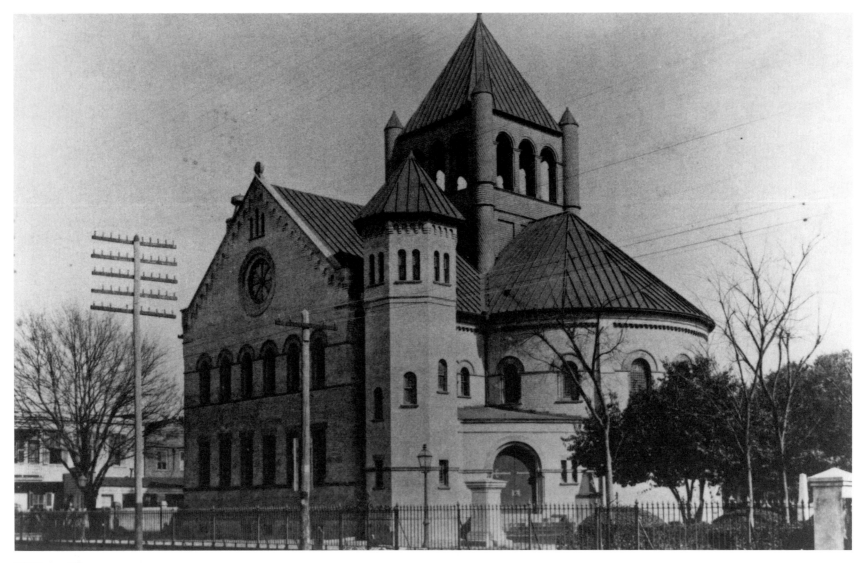

1890s — 23

The Congregational "Circular Church" at 150 Meeting Street occupies the site of a small white church built in 1681, known as the White Meeting House, from which Meeting Street derived its name. By 1804 the congregation had outgrown the White Meeting House, and it was replaced with a handsome church of Pantheon style, designed by Charleston-born architect Robert Mills. It is likely that Mills developed the plans during a two-year stay at Thomas Jefferson's home, Monticello, where he studied architecture in Jefferson's extensive library. The Mills-designed structure was destroyed by fire in 1861, and the Circular Church was constructed in 1890 of brick from the burned building.

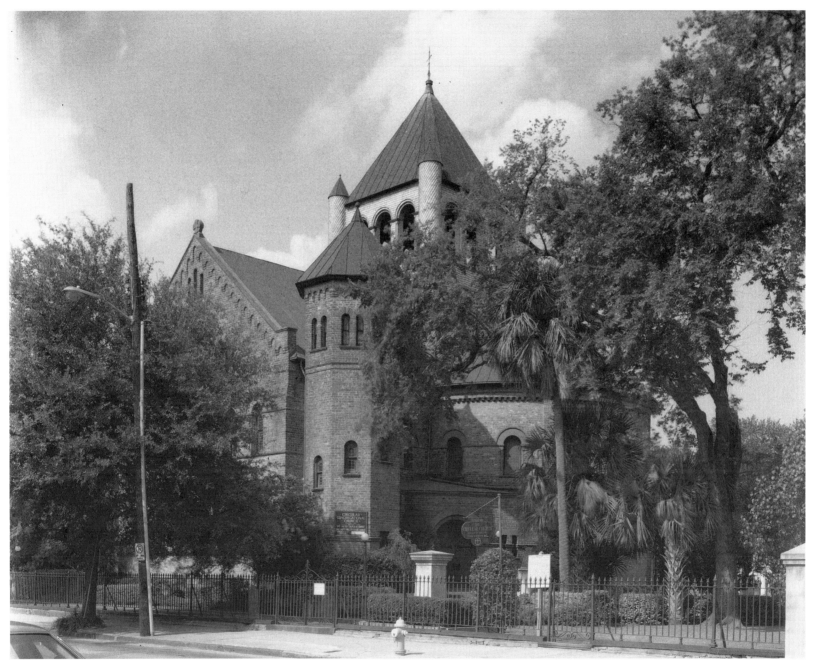

1990s — 23

The Circular Church roof once again resembles that in the photograph taken a hundred years ago, at which time the church had only recently been rebuilt. Many who pass by are unaware that its predecessor, lost to fire, had a portico extending over the sidewalk and a steeple 182 feet high. The church's graveyard is the oldest in Charleston and contains inscriptions, still legible, as early as 1729.

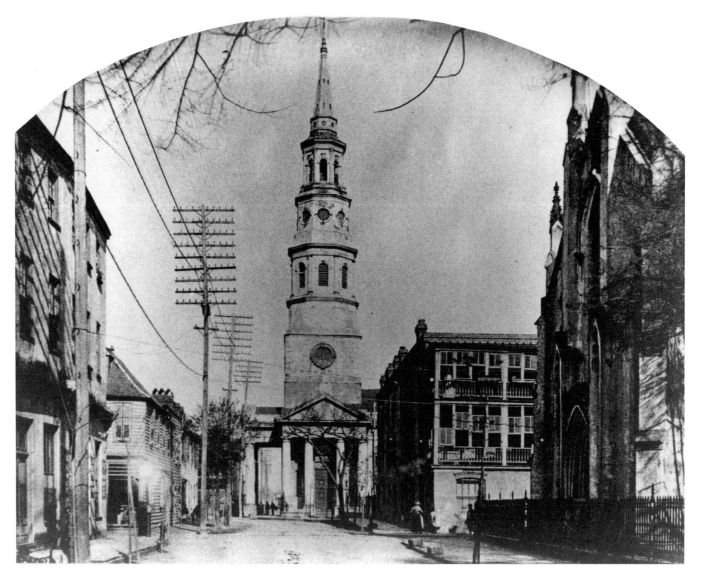

1890s — 24

The corner of Church and Queen Streets in the 1890s—Saint Philip's Church, whose location requires Church Street to bend in a semicircular "detour," was completed in 1838. A similar church erected on this site in 1710 had burned in 1835. The first Saint Philip's was a small wooden church at the present site of Saint Michael's. The structure shown here was about fifty years old when photographed. It had survived the earthquake of 1886 and, prior to that, the War Between the States, during which it was severely damaged and its bells converted into cannon. The French Huguenot Church in the right foreground attests to the origin of some of South Carolina's earliest settlers, many of whom came to America in the late 1600s to escape persecution in France. This Gothic structure, erected 1844-45, was the third sanctuary on this site, the first having been built in 1681.

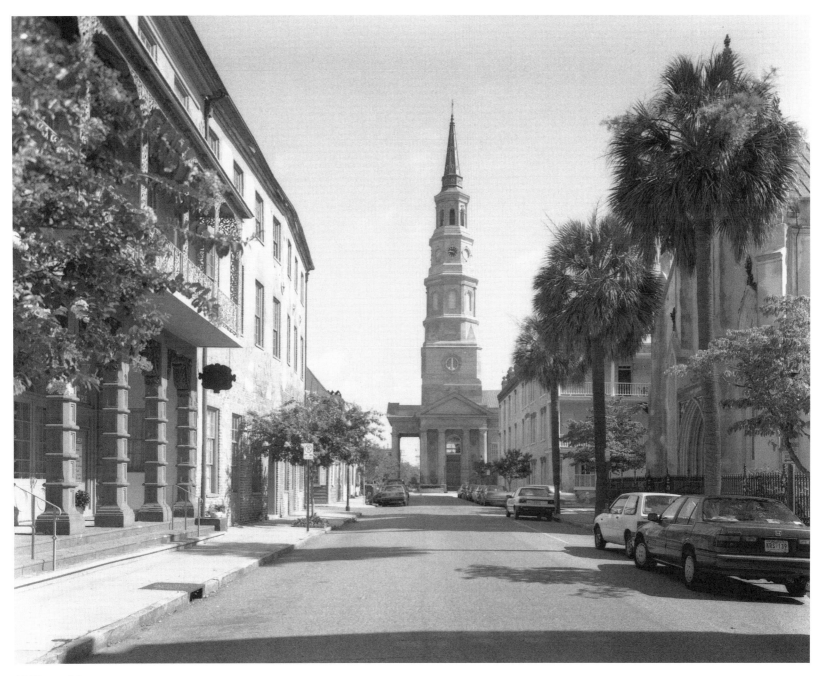

1990s — 24

St. Philip's Episcopal Church received severe damage from the 1989 hurricane. Major repairs were necessary both inside and out, and scaffolding encased the building and steeple for an extended period. The Huguenot Church and Dock Street Theatre have likewise been restored from storm damage and are well-prepared to enter the new millenium.

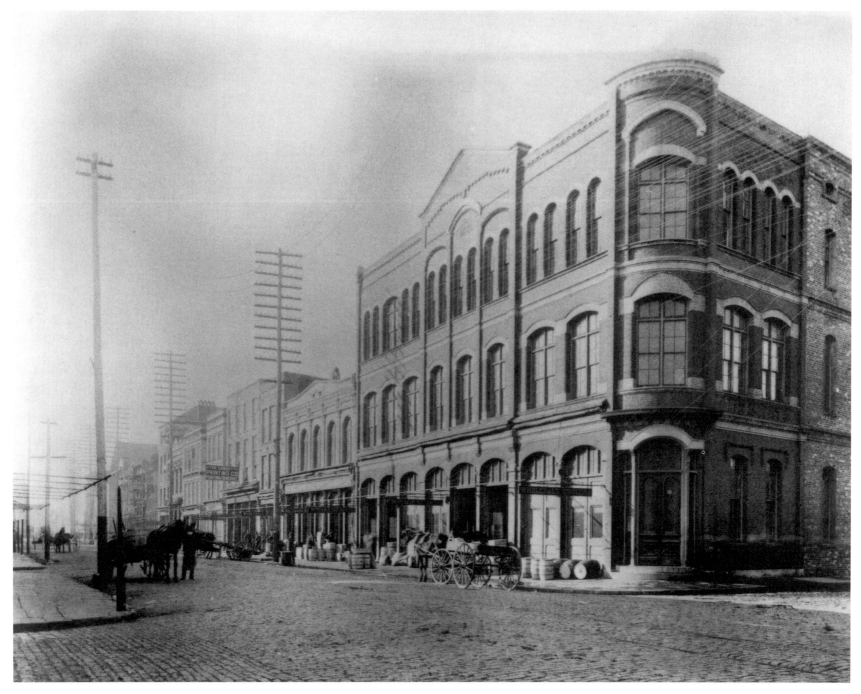

1890s — 25

Scene on East Bay Street at the corner of Queen Street—Part of the original walled city, this section became a center for wholesale commerce because of its proximity to Cooper River wharves.

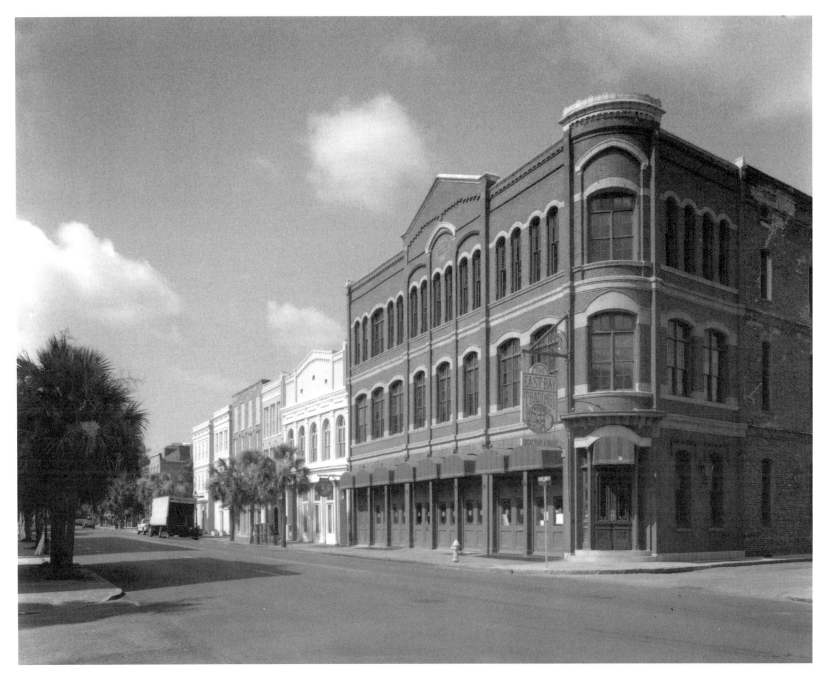

1990s — 25

Change has come to 161 East Bay and a fashionable restaurant now occupies the ground floor. Poles and wires are missing from this view of East Bay Street and palmetto trees have appeared along the sidewalks, marking a new emphasis on aesthetics in this part of the city.

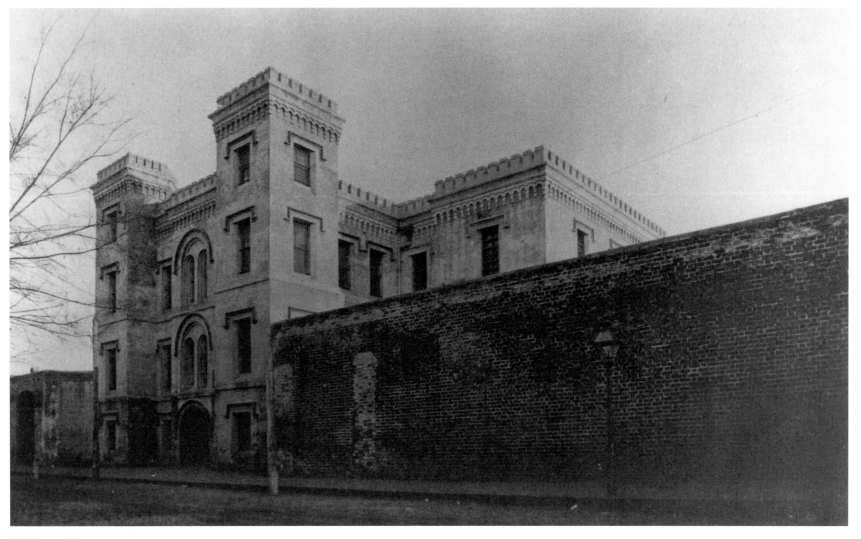

1890s — 26

The jail, stern and forbidding even from the outside, is an antebellum structure remodeled and added to by Robert Mills. Its full brick wall shows the outlines of former arches. This building at Magazine and Franklin Streets housed county prisoners.

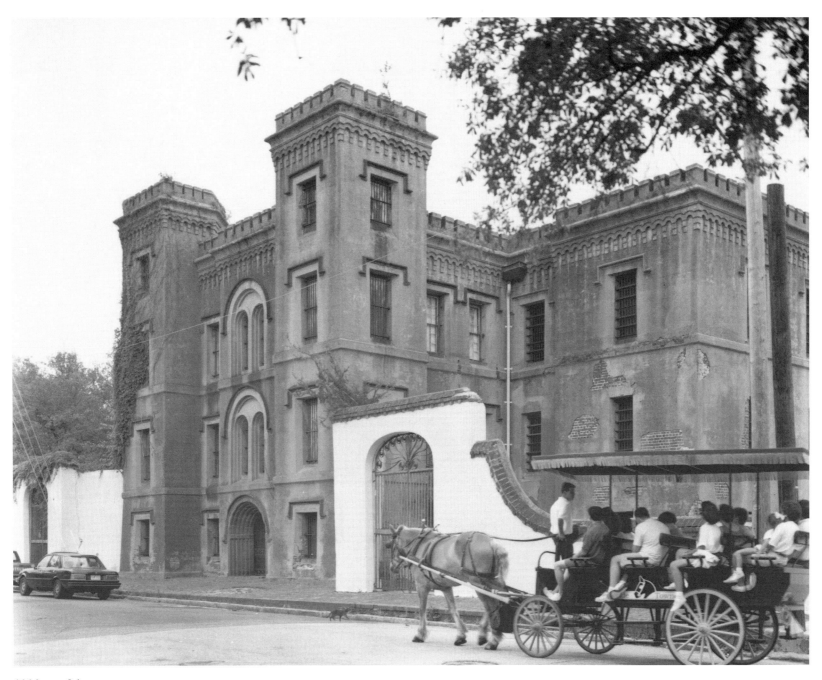

1990s — 26

The towers, battlements, and arches of the old jail suggest a medieval city castle, which in the 1990s attracts tourists by the carriage load.

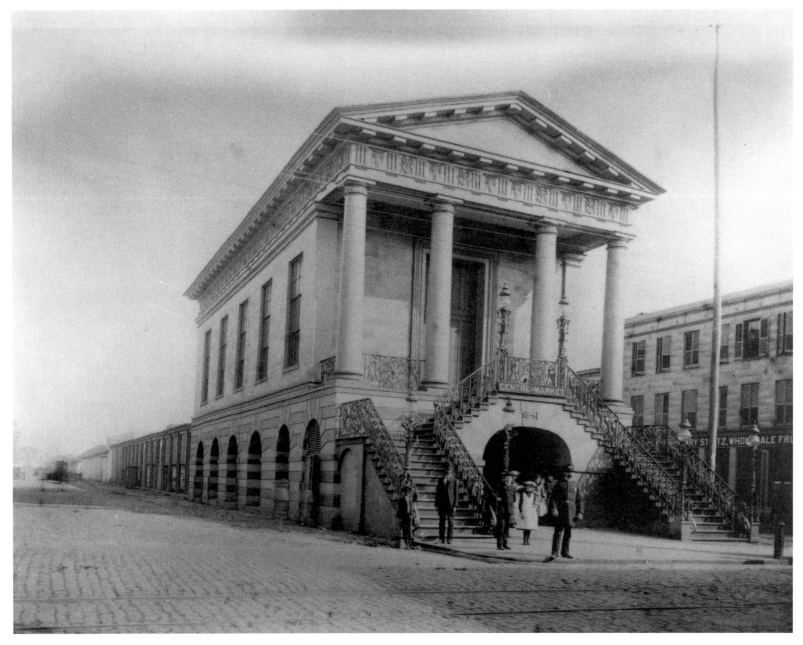

1890s — 27

Centre Market is the site to which local farmers have brought their produce for sale since the late 1700s. The little group gathered behind the policeman in front of the market hall seems to reflect the tranquility of the 1890s. The hall, facing Meeting Street, was designed by E. B. White in Roman Doric style. A series of arcaded market buldings with open stalls extends from the hall to East Bay.

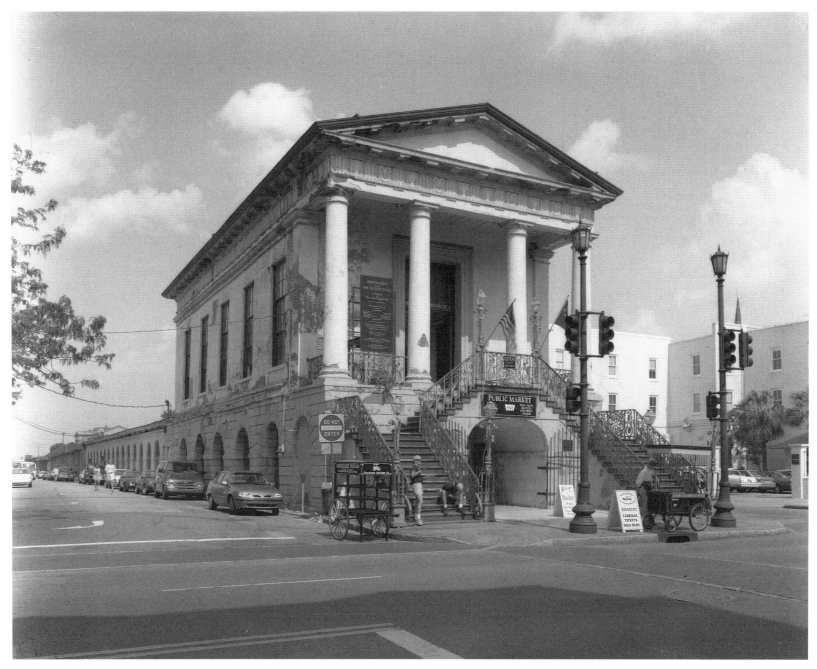

1990s — 27

The public market continues to adapt to wishes and needs of the public. The selling of fresh local produce has now shifted to Marion Square where a "farmers' market" is held on Saturday mornings. Meanwhile vendors arrive at the public market each morning and unload sweetgrass baskets, paintings, and other eye-catching wares calculated to attract customers. The market's growing popularity indicates its success.

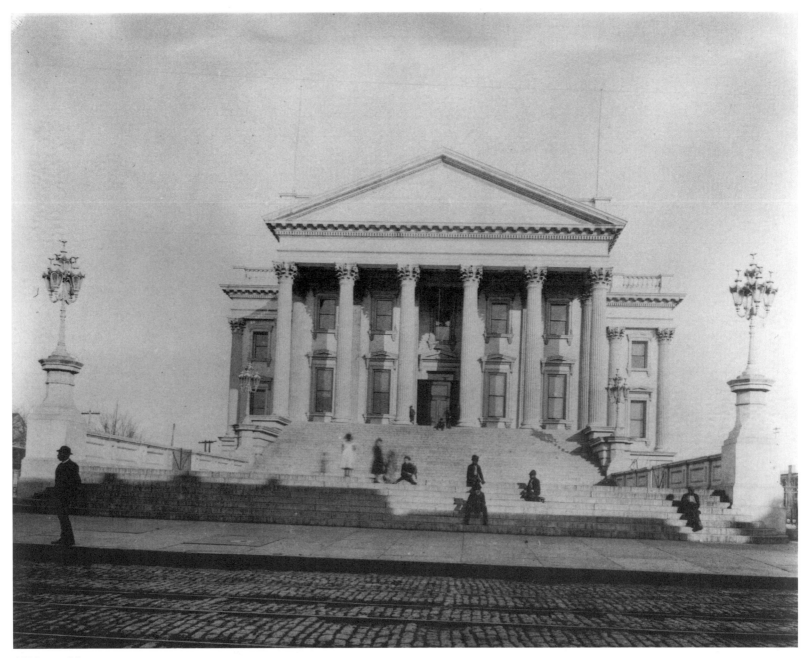

1890s — 28

The United States Custom House at 200 East Bay, begun about 1849, had been completed hardly a decade when this picture was taken in the 1890s! In spite of careful instruction from the photographer, someone moved at the center of the picture, resulting in a blur. The man at left may be waiting for the "belt-line" trolley.

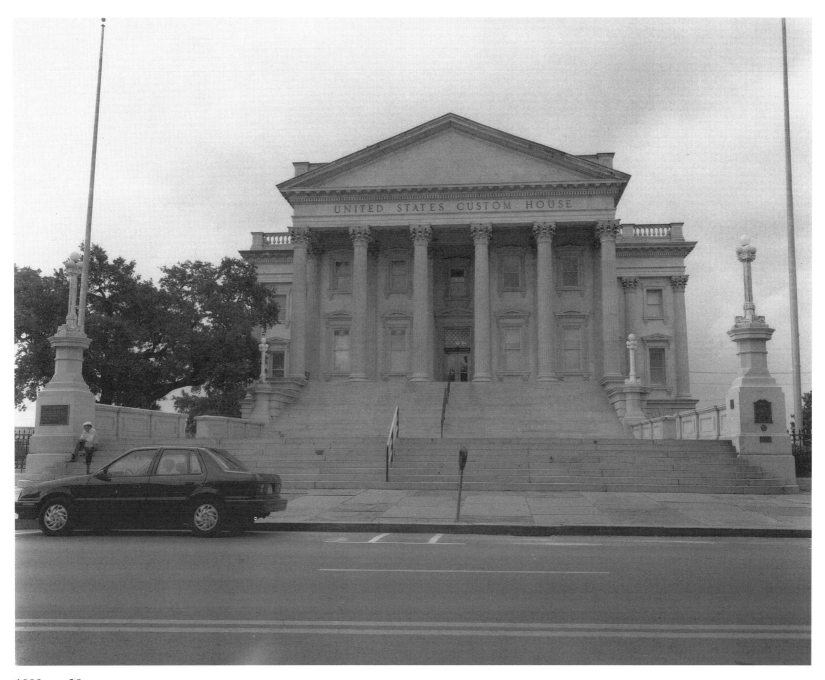

1990s — 28

The stately Custom House, although located just across East Bay Street from the public market's eastern end, seems to share little of the mass attraction its neighbor enjoys.

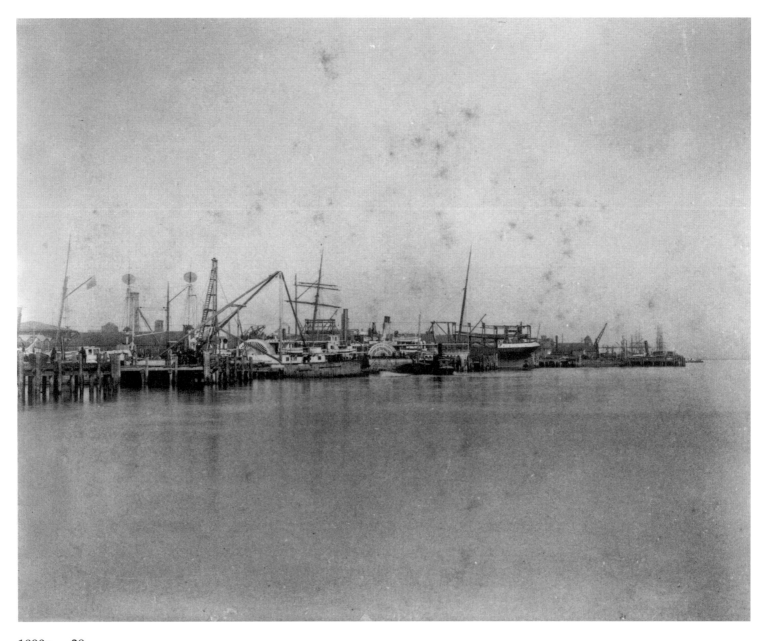

1890s — 29

View of Cooper River docks looking north—The Charleston waterfront was bustling with activity when this picture was taken. Sidewheel steamers occupy docks in the foreground, while masts of sailing vessels are visible beyond.

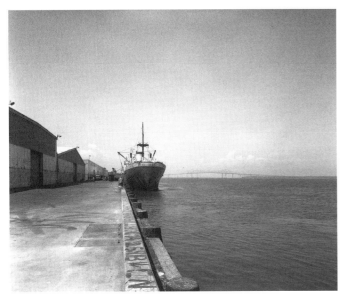

Looking up the Cooper River from South Carolina State Ports Authority Pier No. Two.

1970s — 29

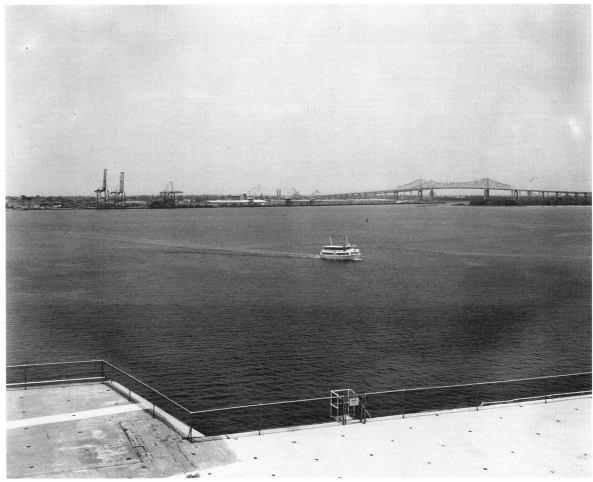

Sight-seeing boats now tour the harbor in growing numbers. The Cooper River bridges seen on the horizon are part of the coastal highway system. Further upriver the Naval Base is in process of conversion to other uses as part of a nationwide reduction in defense facilities.

1990s — 29

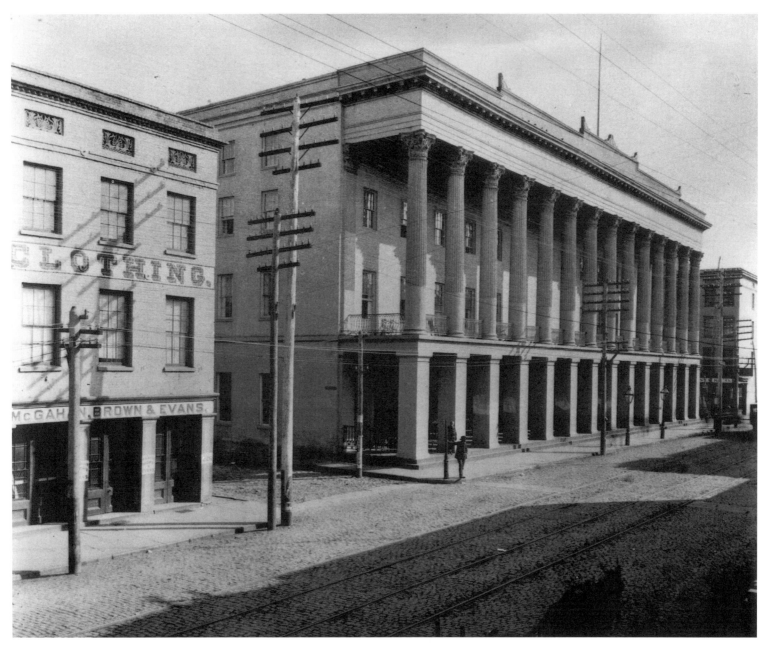

1890s — 30

The Charleston Hotel stood in quiet Greek Revival elegance this sunny day in the 1890s, as a lone passenger awaited the approaching trolley car. The hotel front on Meeting Street occupied the entire block between Pinckney and Hayne Streets. From its balcony Henry Timrod looked down on a torchlit parade making its way to the Battery after the signing of the Articles of Secession in 1860.

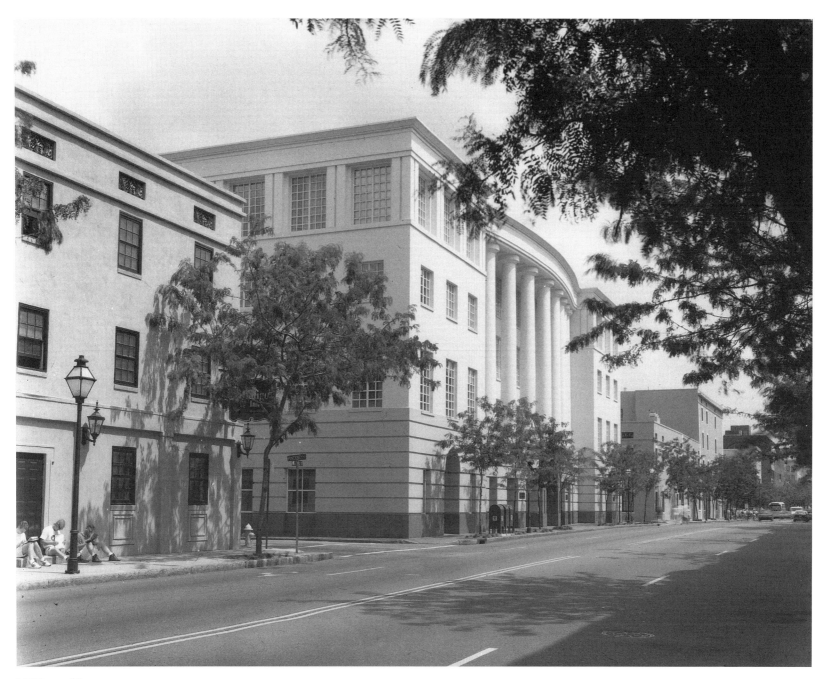

1990s — 30

Some of the elegance of a hundred years ago was returned to this area of Meeting Street in 1991 when NCNB, subsequently NationsBank, completed this office building. It is located on the site of the old Charleston Hotel, razed a number of years earlier, which seems to have influenced the new building's design. The view is further enhanced by the addition of trees and elimination of utility poles.

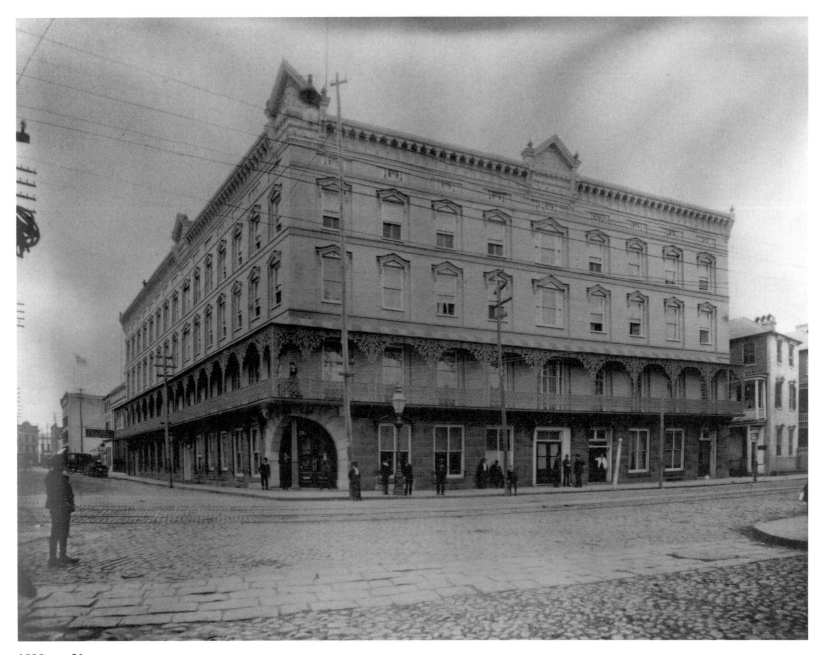

1890s — 31

First known as the Pavillion Hotel, renamed the Saint Charles Hotel in 1881, and still later called the Argyle, this building located at the bend in Meeting Street at Hasell seems to have been a popular place for sidewalk gathering this day in the 1890s. Even the barber has come to the doorway to have his picture made for posterity. A young woman, attracted by the excitement, watches from behind the lacy ironwork of the balcony.

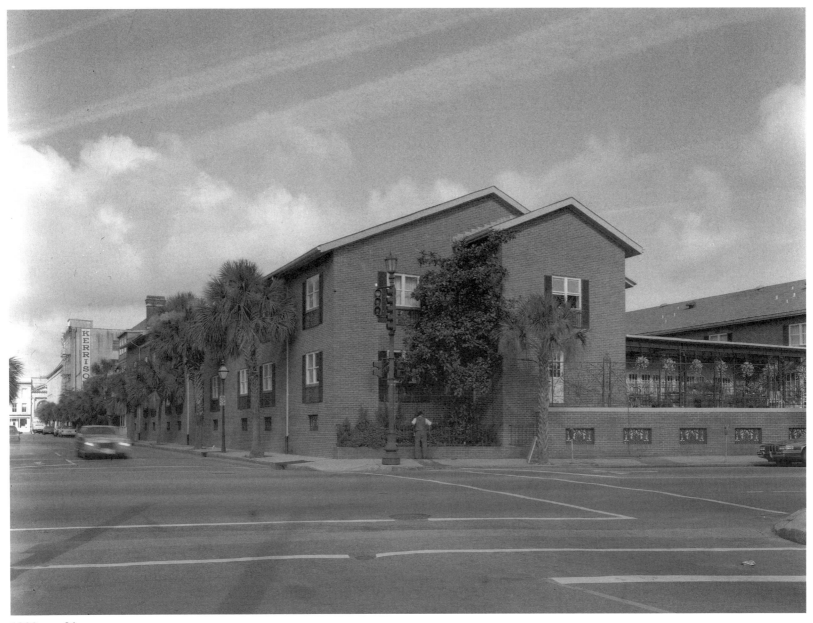

The changing requirements of the traveling public are once again reflected in the transition from hotel to motor inn, now the King Charles Inn. Looking very much the same, however, is the building at left down Hasell Street, part of Kerrison's department store.

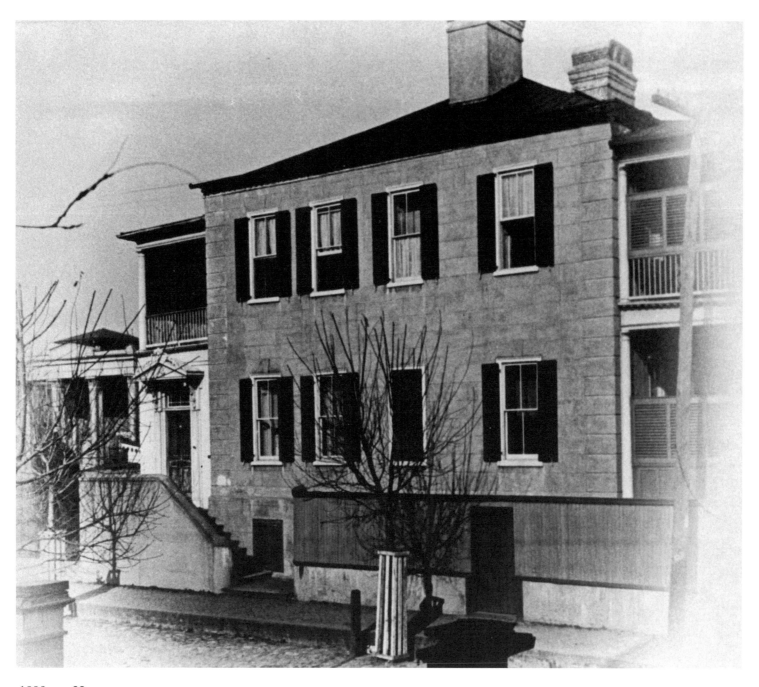

1890s — 32

Colonel William Rhett, who was also vice admiral of the Province, built this house about 1712 on his plantation located just north of the walled city of Charles Town. Rhett, who was in charge of military and naval forces in the Province, had recently led the local militia in repulsing attacks by the Spanish and French. In 1718 shipping out of Charles Town was being attacked by pirates who lay in wait off the coast. Colonel Rhett with two ships sailed out to do battle and captured the pirate leader, Stede Bonnet, and thirty of his crew. Ten years after building this house Colonel Rhett died but his family retained the property until 1807.

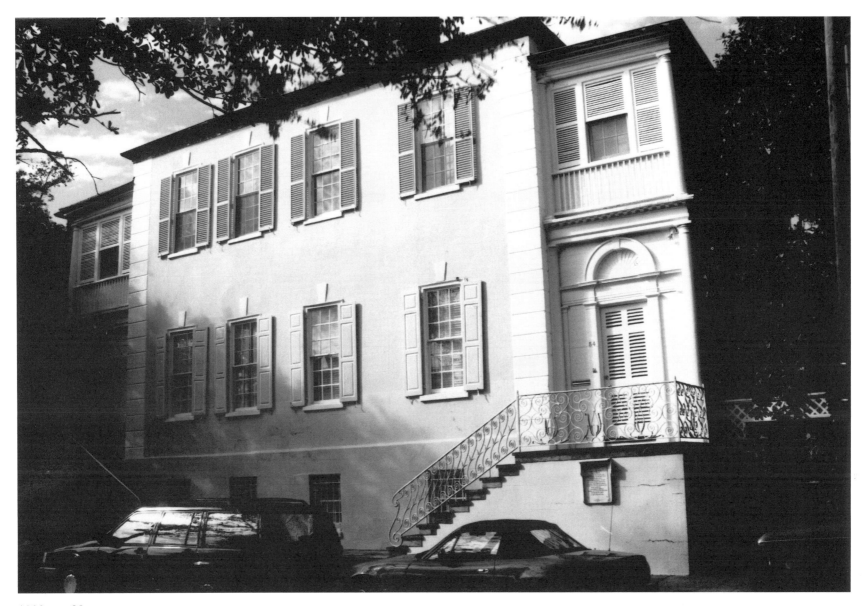

1990s — 32

The Colonel William Rhett House at 54 Hasell Street is the oldest house in Charleston and has been designated of national importance. It has withstood fires, wars, hurricanes, and a major earthquake, and was the birthplace of Wade Hampton, famed Confederate general and governor of South Carolina. The piazzas and double entrance stairs have been added to the original house. Restorations were made in the 1930s by the Kittredge family who also presented Cypress Gardens to the city of Charleston.

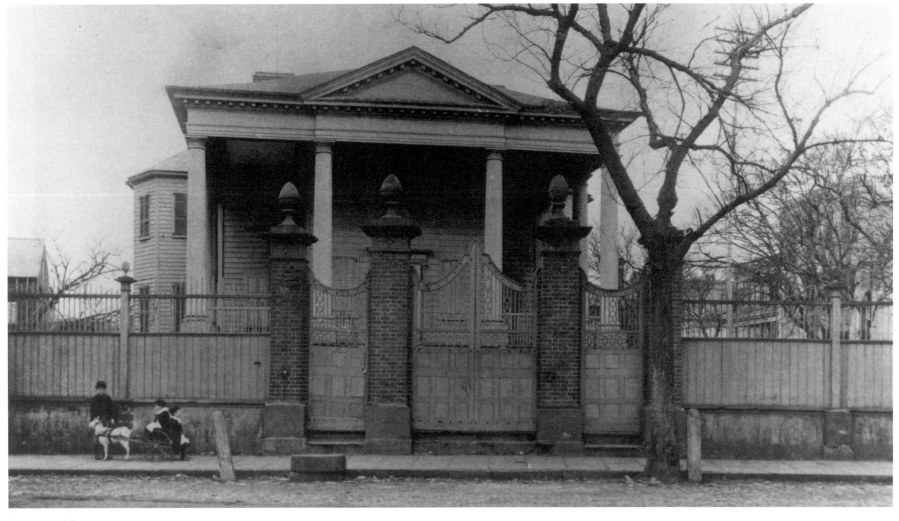

Home of Nathaniel Heyward, built about 1788, at the corner of East Bay and Society Streets—Three young Charlestonians have reined in their goat to pose for the photographer.

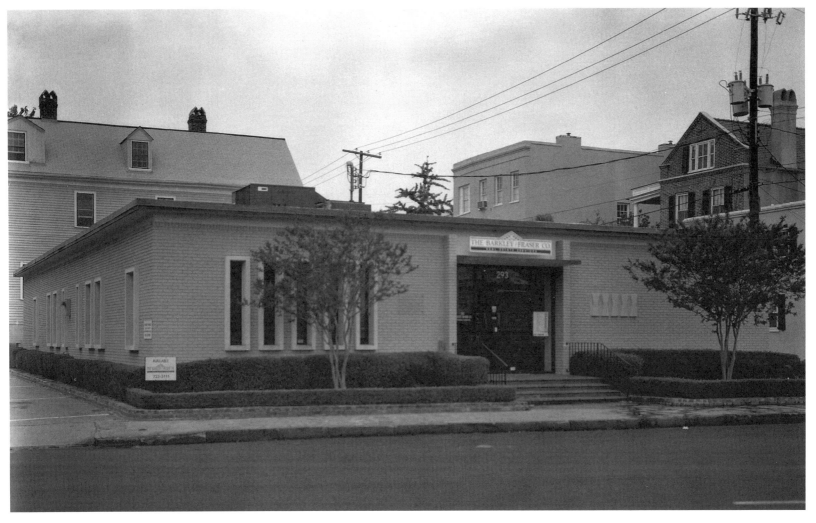

1990s — 33

The Heyward House was in great part destroyed about 1920. An office building now occupies the site.

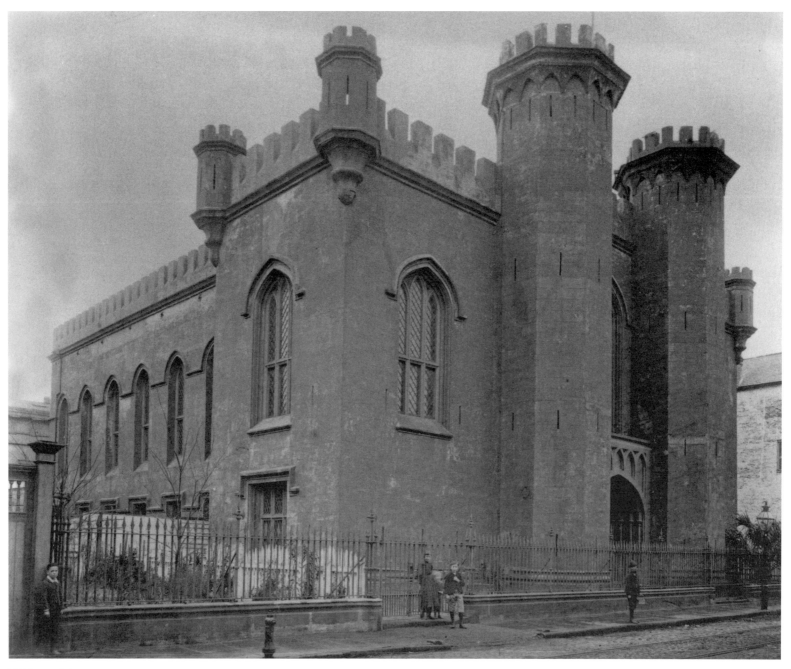

1890s — 34

The German artillery hall, on Wentworth Street between King and Meeting, could easily be taken for an urban castle in some European town. Its towers, battlements, and spear-tipped fencing lend a martial atmosphere.

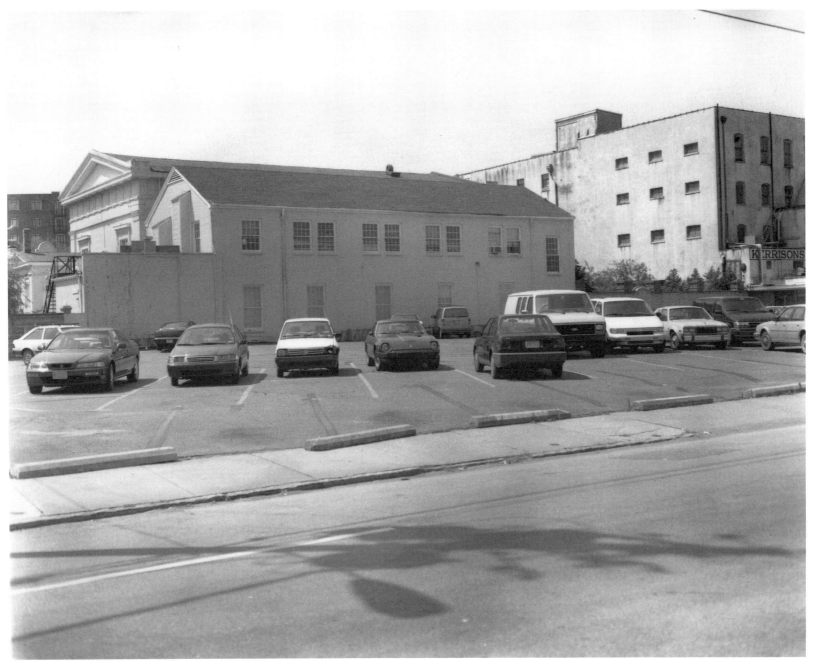

1990s — 34

Gone, as though it had never been, is the German Artillery Hall leaving a parking lot at its old locaton. The old fencing now fronts the Gibbes Art Gallery. At far left is the Congregation Beth Elohim Reform Temple, the second-oldest synagogue in the United States. This structure was built in 1840 on the site of a 1792 synagogue that had been destroyed by fire.

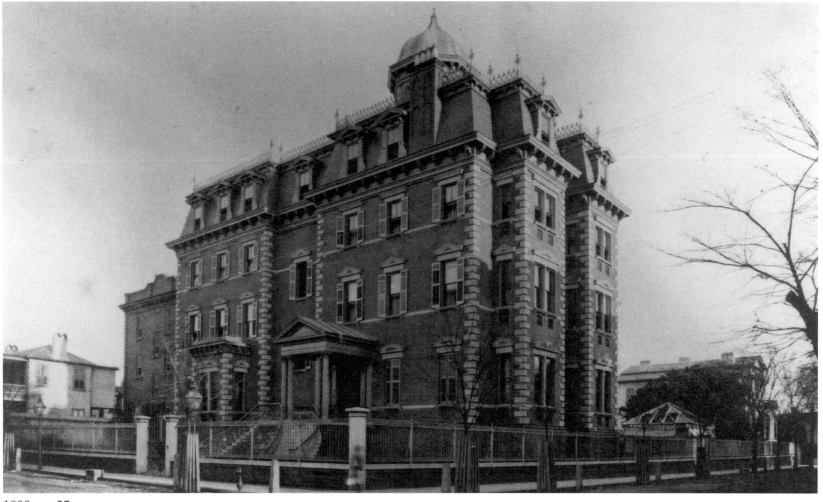

1890s — 35

The F. S. Rogers residence on Wentworth Street was perhaps the largest house in the city in the 1890s. It is said that Mr. Rogers wanted room for any or all of his children and their families to live with him. There was once a tennis court on the roof.

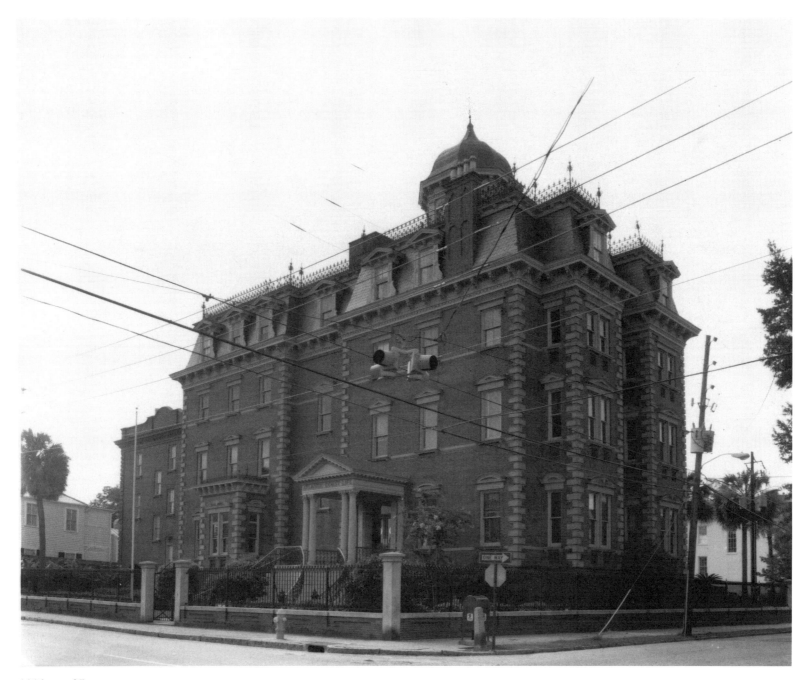

1990s — 35

Home offices of the Atlantic Coast Life Insurance Company now occupy this building, an interesting example of the trend among Charleston business firms of adapting old buildings to their needs, rather than replacing them. Some of the old hitching posts still remain at the side curb.

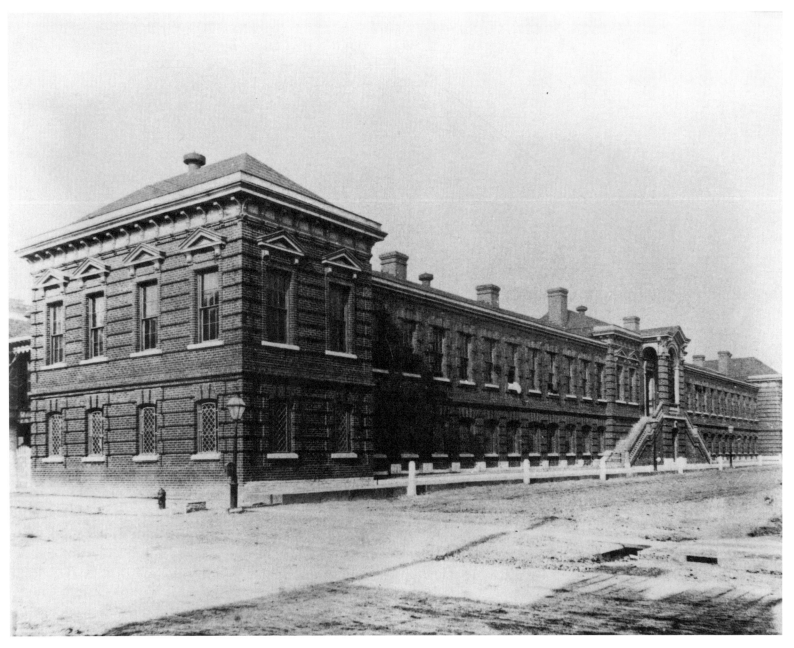

1890s — 36

Old Roper Hospital was about five years old when this photograph was taken in the 1890s. Located at the corner of Lucas (now Barre) and Calhoun Streets, it served as the city hospital. The first Roper Hospital, part of which still stands at 140 Queen Street, had been badly damaged in the 1886 earthquake, and the city decided a new hospital should be built rather than trying to repair the old one.

The area where old Roper Hospital once stood continues to fill with buildings relating to the medical profession. The sign near the roofline of the building at the bottom identifies it as part of today's Roper Hospital system.

1970s — 36

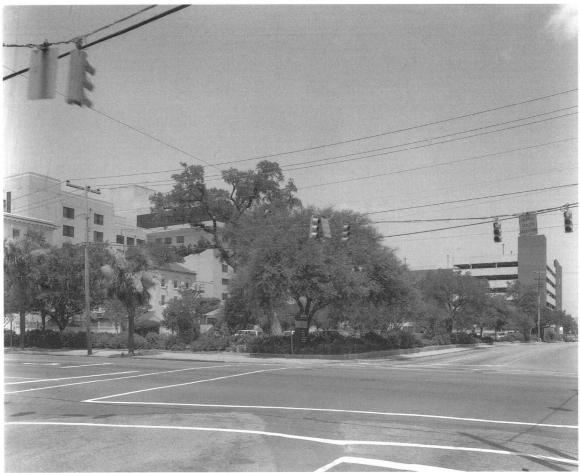

1990s — 36

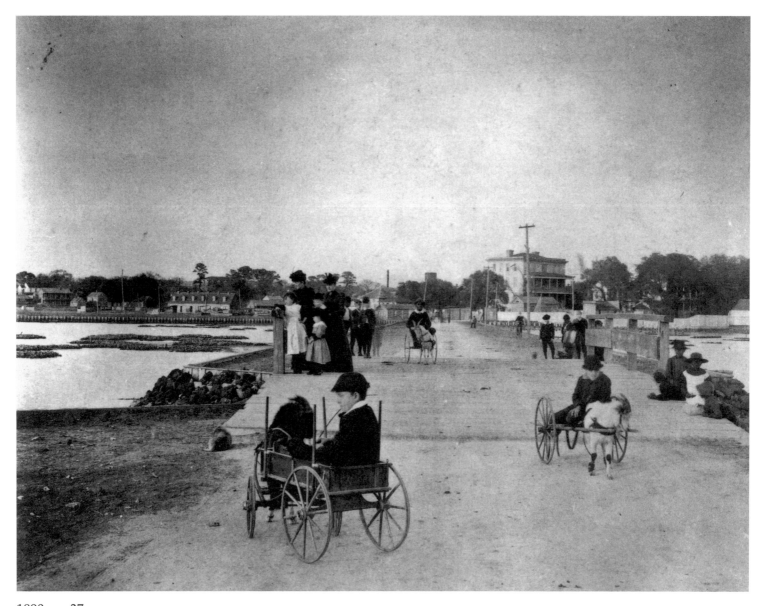

1890s — 37

Porgy, as he traveled the streets of Charleston in his goat cart, would have been a natural part of this gathering on the causeway connecting Calhoun Street with the West Point Rice Mill. The old arsenal buildings of Porter Military Academy can be seen over the rooftops at left while to the right is the Jonathan Lucas home.

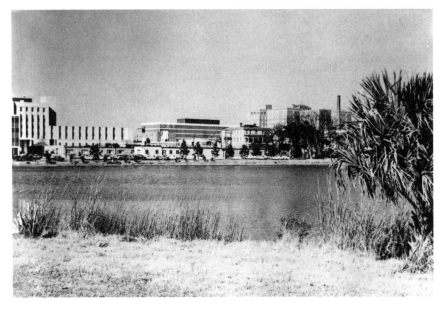

When Jonathan Lucas built his large home 186 years ago on what was then the northern boundary of Charleston he could little have imagined that it would someday be dwarfed by the medical complex that grew up around it. In the 1990s photo one must look closely to find it nestled slightly to the right of the center building.

1970s — 37

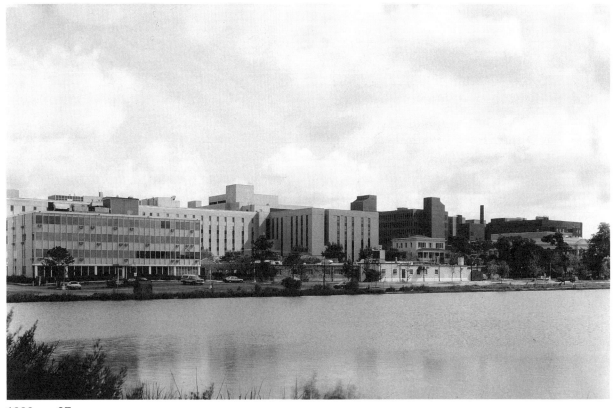

1990s — 37

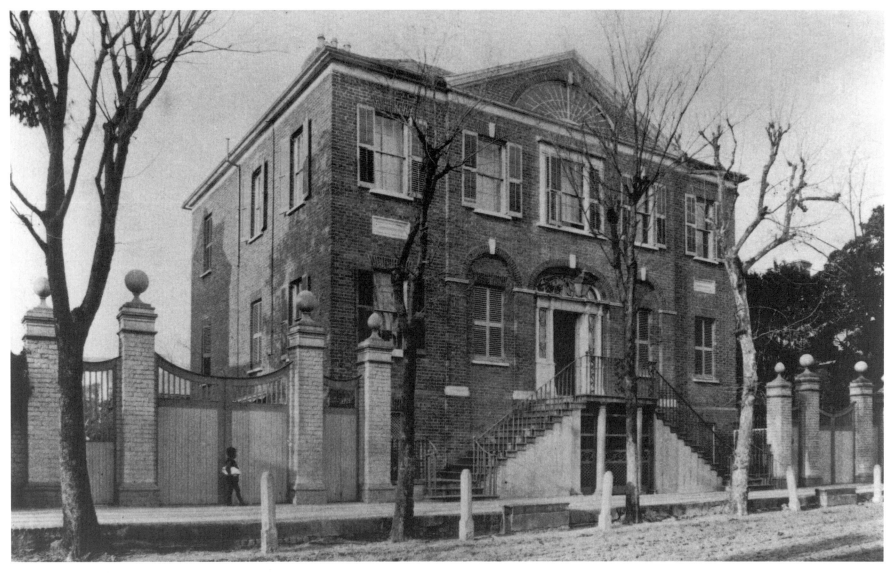

1890s — 38

The Blacklock House at 18 Bull Street is considered of national importance because of its distinguished architecture. Built in 1800 by the Clarkson family, it was the residence of Jacob Small at the time of this photograph. The boy at the gate appears patently unconcerned that his picture is being taken.

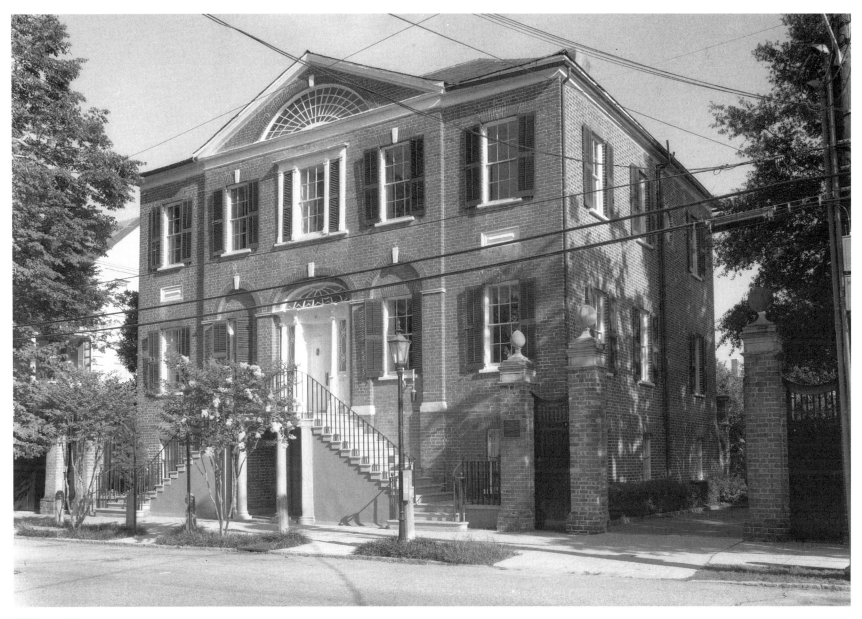

1990s — 38

This elegant "double house," which is nearing its 200-year mark, provides an excellent example of the care that has been given many of Charleston's fine old homes. This scene was photographed from the opposite angle due to the dense foliage obscuring the original view.

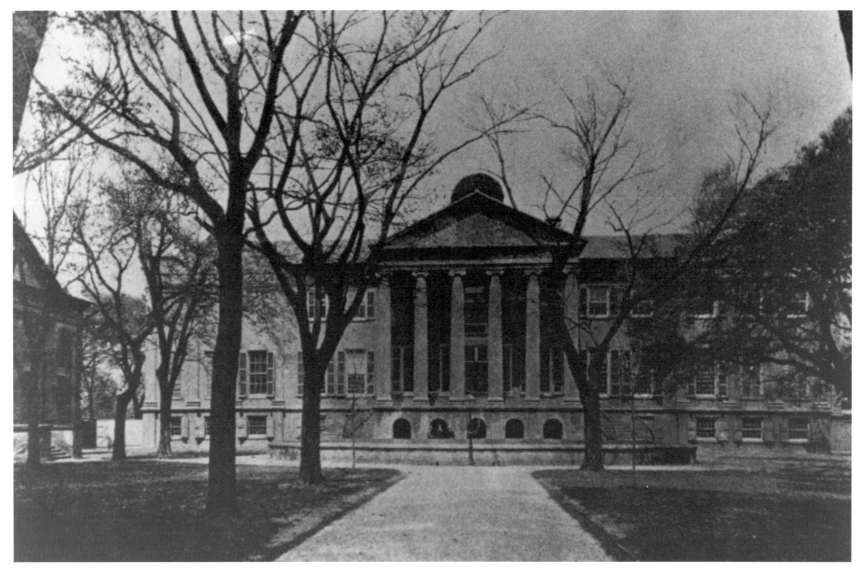

The College of Charleston, first municipal college in America, was chartered in 1785 and opened in 1790. It faces George Street between Glebe and Saint Philip Streets. When this site was chosen it was just south of the city's fortified tabby wall along Calhoun Street. Students during the early years used a converted militia barracks from French and Indian War days, which formerly stood near the building at left in this photograph. The handsome Greek-Revival building pictured here was designed by William Strickland. Construction was begun in 1828, paid for with voluntary gifts from Charleston citizens.

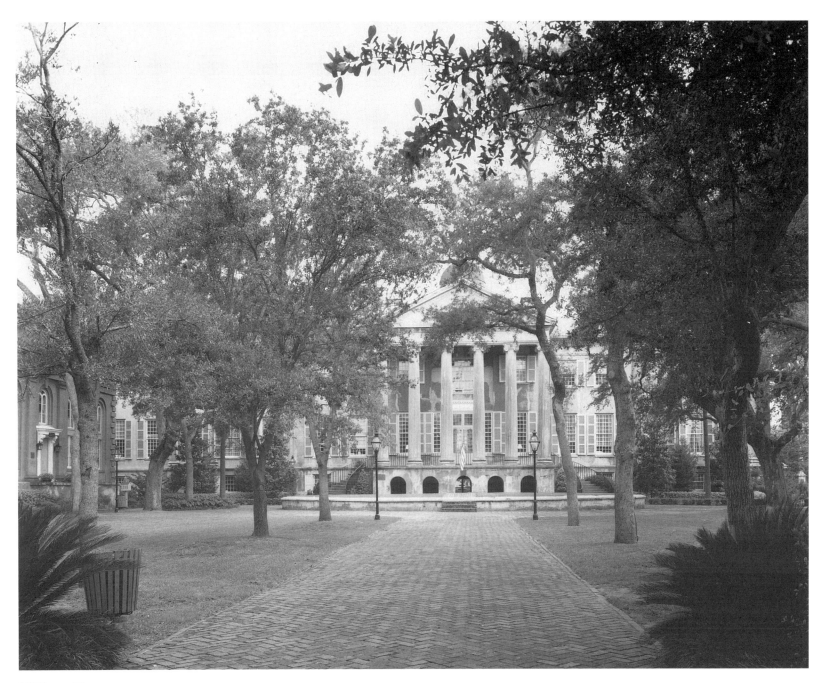

1990s — 39

Although located in the heart of Charleston the College has skill-fully managed to continue growing to meet its expanding need for space. This current picture suggests it has maintained the in-tegrity of its campus throughout the growth period. Its last major additions were the building wings and the stately portico designed by Charleston architect E. B. White in the 1850s.

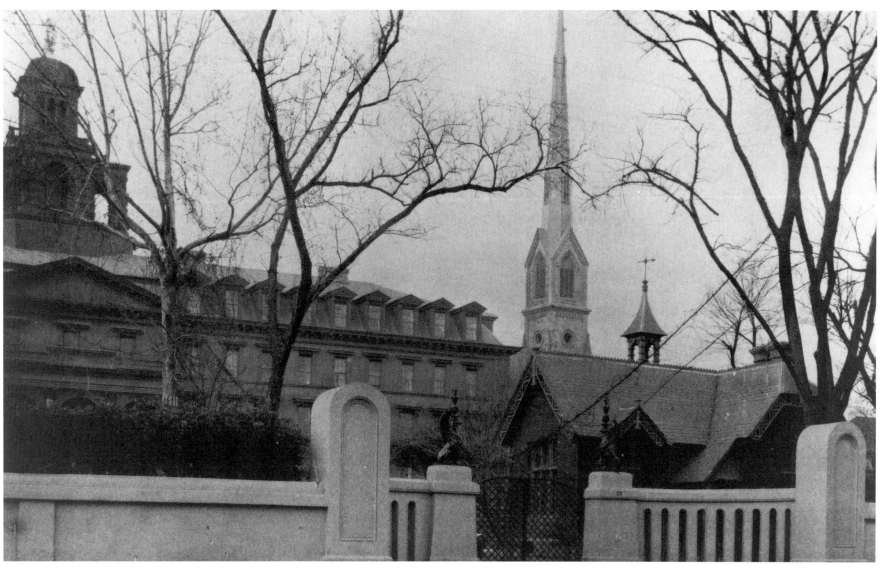

1890s — 40

The Gothic steeple of Saint Matthew's Lutheran Church, 405 King Street, rises from behind the Charleston Orphan House in this 1890s view. Saint Matthew's was begun only two years after the Civil War ended—an unusual time for building in the South—and was completed in 1872. The Church provided a school for several hundred children at that time. The Orphan House, built in 1792 and remodeled in 1855, faced Calhoun Street between Saint Philip and King Streets.

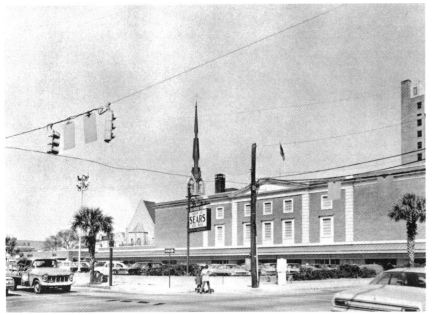

It is fitting that the site of the old Orphan House has again been returned to serving youth. The Sears Building seen in the 1970s photo has become part of the College of Charleston complex. So has the parking lot at Calhoun and Saint Philip Streets where a new college building has been erected.

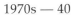

1970s — 40

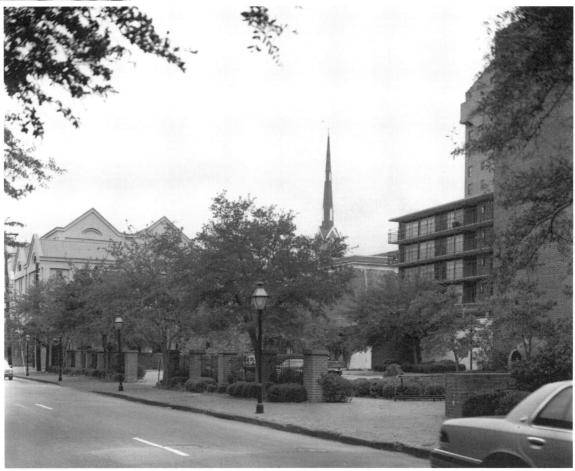

1990s — 40

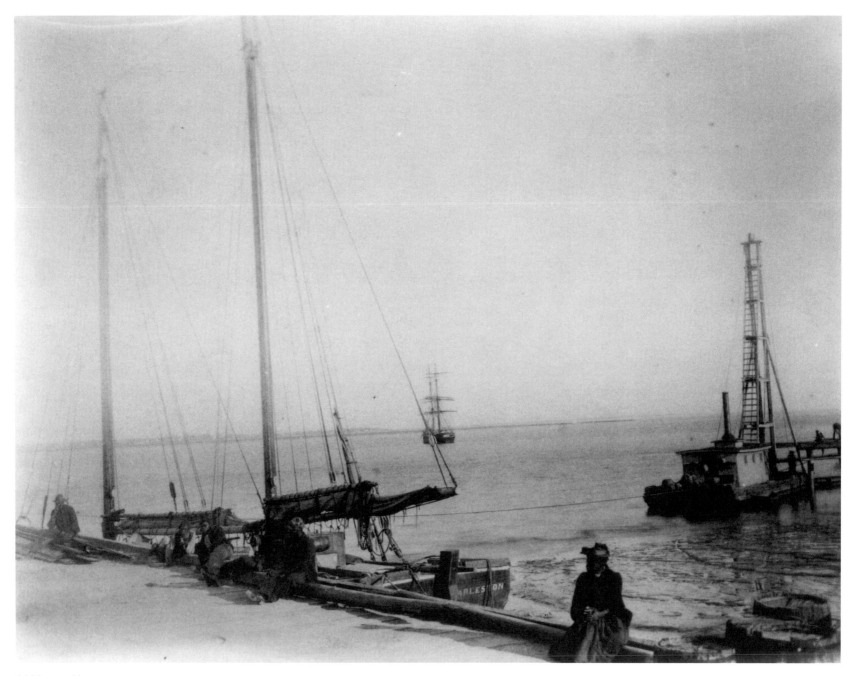

1890s — 41

Quaint scene from Marshall's Wharf near the eastern end of Calhoun Street—A schooner lies at anchor in the harbor, while at right a pile-driving rig is used in adding a new section of wharf.

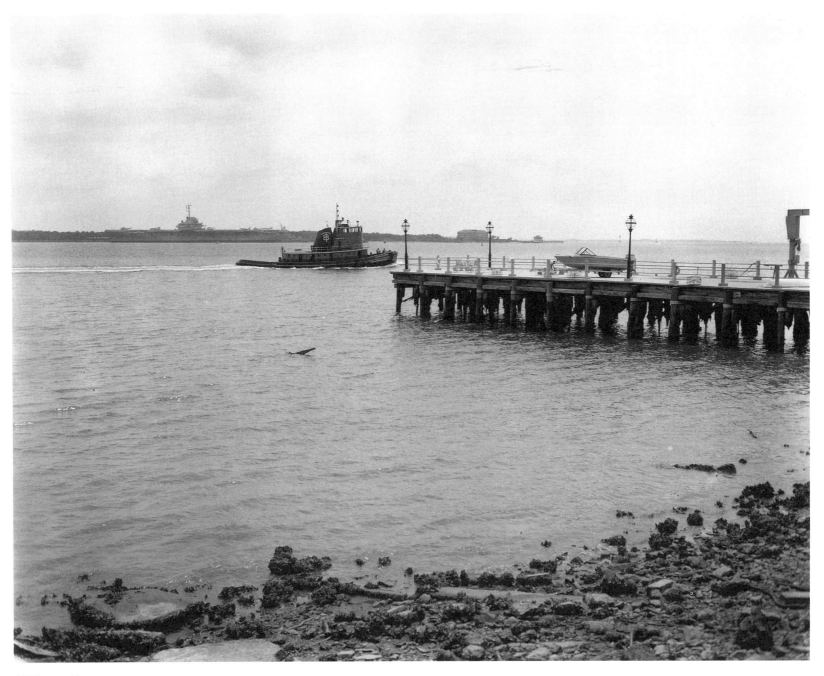

1990s — 41

The site of Marshall's Wharf at the Cooper River end of Calhoun Street is to be the location of the South Carolina Aquarium, soon to be built. The Fort Sumter Tour Boat Facility will also be located here.

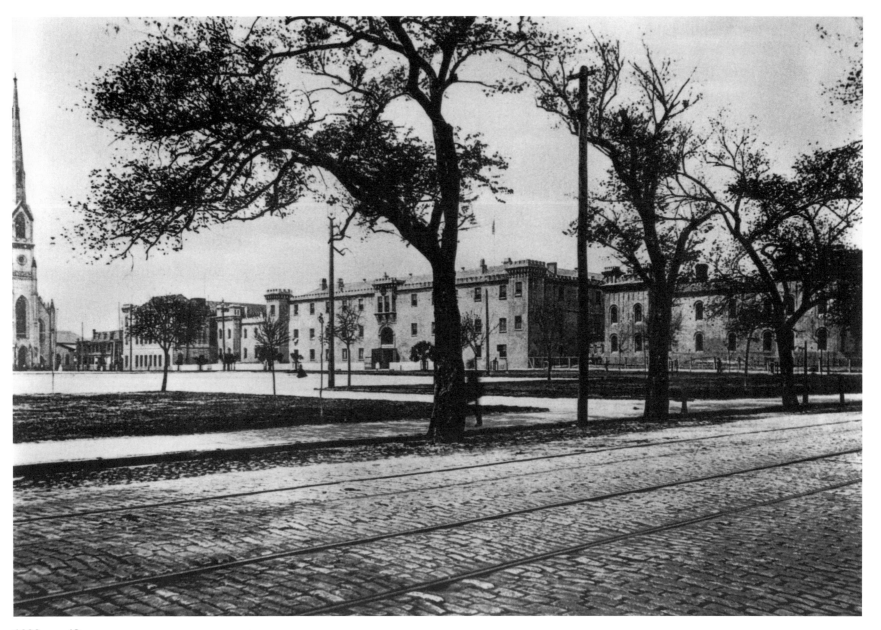

1890s — 42

The Old Citadel, viewed across the trolley tracks and paving stones of Meeting Street at Marion Square, had housed the Citadel Cadet Corps for fifty years at the time of this photograph. The original building, erected in 1822 for troop garrisoning, was modified twenty years later and received its first contingent of twenty cadets in 1843. Many early Citadel graduates distinguished themselves in the War Between the States. A detail of Citadel cadets, manning a battery of twenty-four-pound guns on Morris Island near Fort Sumter on January 9, 1861, prevented the United States ship *Star of the West* from delivering supplies to federal troops at the fort. Their shots are generally considered to have been the first of the War. At far left in the photograph is Saint Matthew's Lutheran Church.

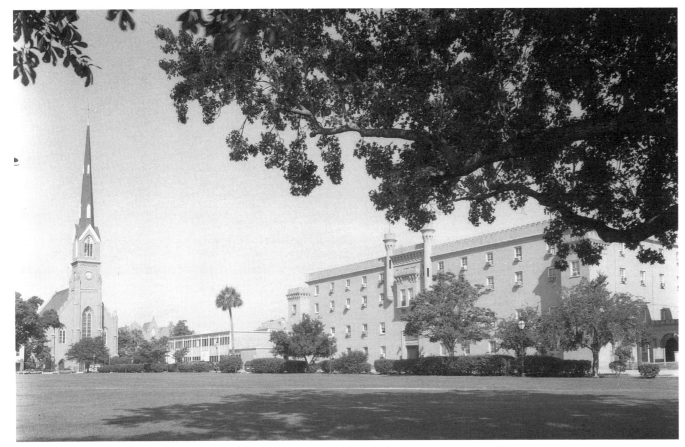

1990s — 42

In 1922, The Citadel moved to its present site on the Ashley River as shown at lower right. Above, the Marion Square area is again adapting to Charleston's changing needs. The Old Citadel building is being established as an inn while a "farmer's market" for selling local produce now assembles at the Square on Saturday mornings. All the while St. Matthew's Church watches serenely over the scene.

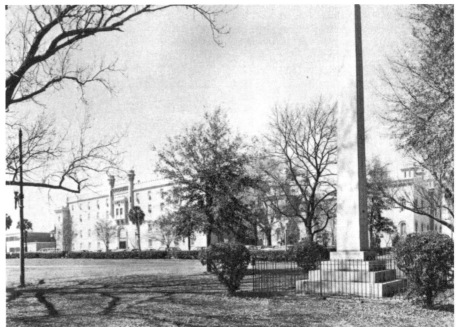

1970s — 42

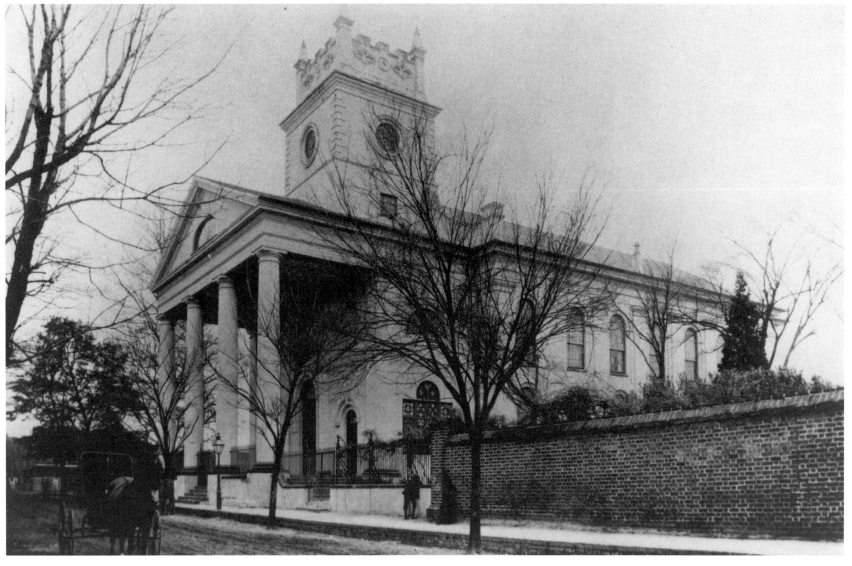

1890s — 43

Saint Paul's Church at 126 Coming Street as it looked in the horse-and-buggy days of the 1890s—When built in 1811 the church was a part of Radcliffborough, then a popular suburb numbering many wealthy rice planters among its property owners.

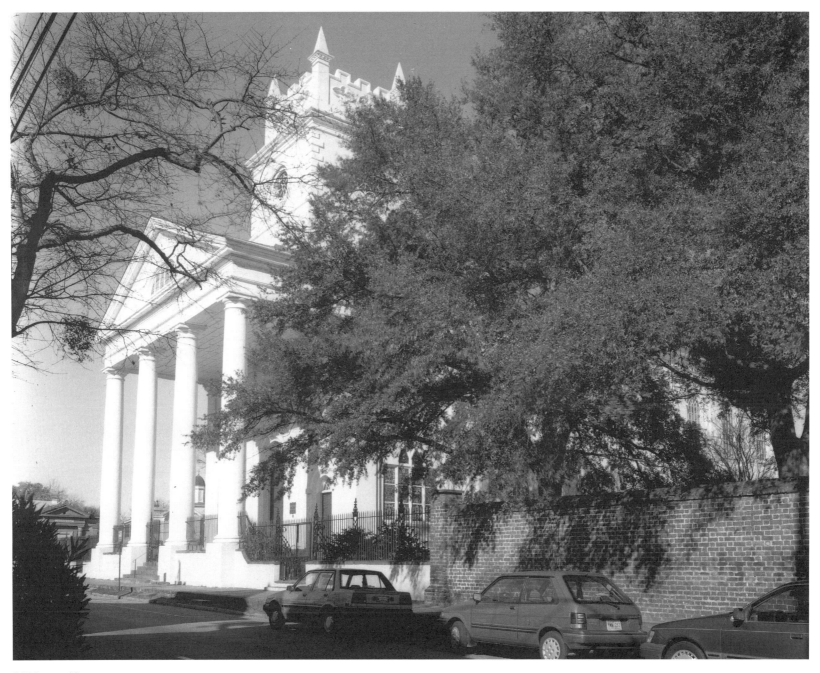

1990s — 43

The dignified portico and crenelated tower of the Episcopal Cathedral of Saint Luke and Saint Paul gleam white on a sunny day as this cathedral church continues its mission towards a new millenium.

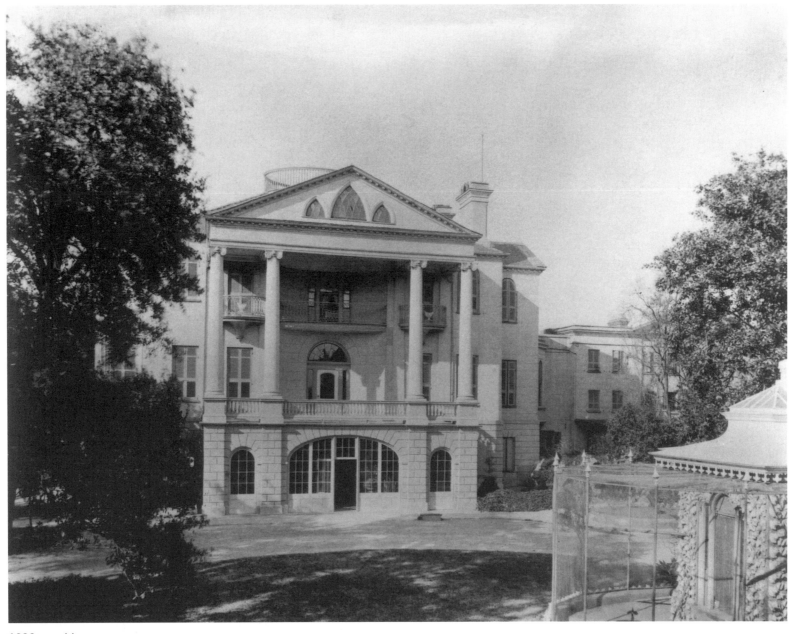

1890s — 44

The Patrick Duncan House at 172 Rutledge Avenue was built about 1816 in the suburb of Cannonborough. The beautiful estate was the home of the Witte family at the time of this photograph.

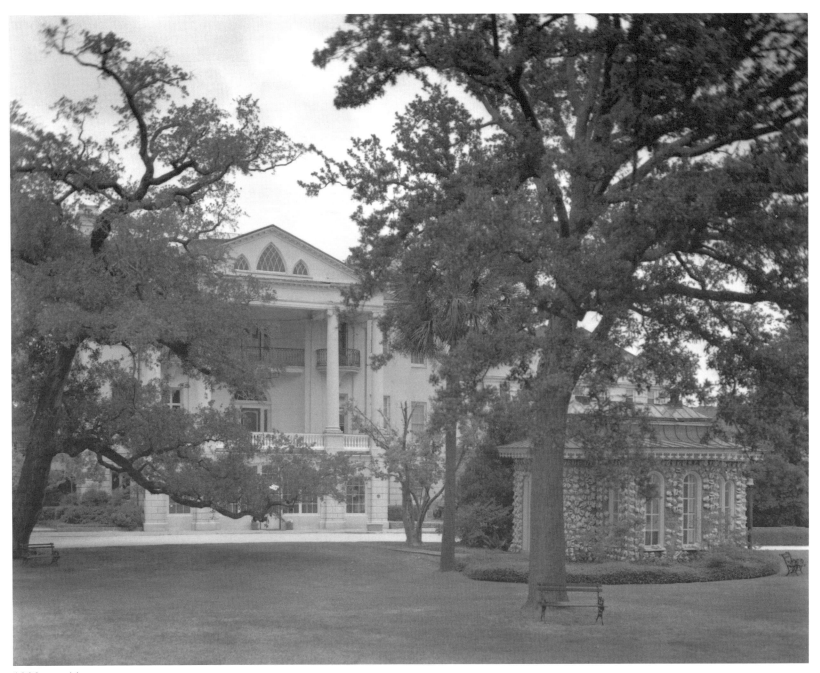

1990s — 44

Ashley Hall, a fashionable school for girls, was established here during the interval between pictures. Though it is not generally known, the school at one time accepted boys through the third grade, and among its early "graduates" was one of this book's authors. In the manner of many of Charleston's fine old buildings Ashley Hall has changed little through the years. Among its noted alumnae it now includes Barbara Bush and novelist Alexandra Ripley.

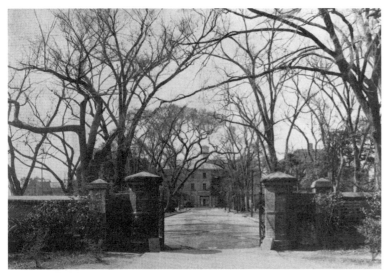

1890s — 45 A-1

Entrance to Porter Military Academy of old from Ashley Avenue showing Hampton Hall Barracks in the distance and a part of Hoffman Library at far right. The School occupied the nine-acre site of the old Federal Arsenal bounded by Ashley Avenue and President, Bee, and Doughty Streets.

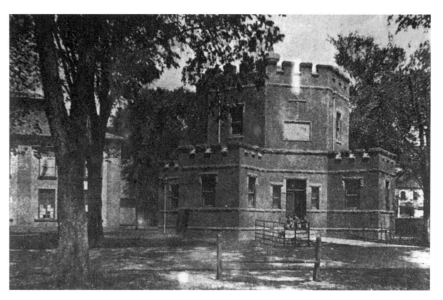

1890s — 45 A-3

Hoffman Library, built 1893-94, was named for the Reverend Charles F. Hoffman, a Northern friend of Doctor Porter's, who provided the building funds. Colcock Hall is seen at left of the library, St. Timothy's Chapel at right.

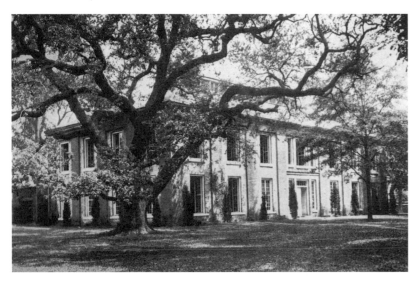

1890s — 45 A-2

Colcock Hall, named for Professor Charles J. Colcock, the venerable Headmaster of Porter Academy, was built by the Confederates in 1861 to make and repair artillery. Originally named Butler Hall, the building was converted to academic use by Doctor Porter.

The Porter Military Academy was founded in 1867 by the Reverend Dr. A. Toomer Porter as the Holy Communion Church Institute to educate young men whose families had been impoverished by the Civil War. In 1880 the school moved to the Federal Arsenal, which had been built prior to 1830 and was no longer needed by the government. Shortly after the move the school name was changed to The Porter Military Academy. Buildings as pictured on this page changed little from the 1880s and 1890s well into the 1900s, and long after Doctor Porter's death the school continued to turn his dream of educating youth into reality.

Then in 1964 new needs and opportunities combined to bring about major changes. The old school property was sold to the expanding Medical University of South Carolina, and Porter Military Academy was combined with Gaud School on a new site to form Porter-Gaud School. The results have been very successful. Doctor Porter's mission of education continues at both sites.

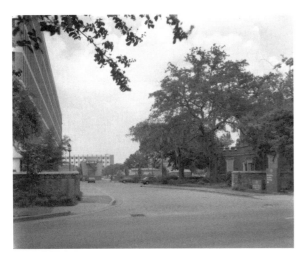

1990s — 45 B-1

The entrance to the Medical University of South Carolina (MUSC) has been widened to accommodate larger vehicles. But the old brick fence shown at each side of the photo ties it to old Porter Academy. So does the library at right, which keeps company with its larger MUSC neighbor at left. The Medical University was able to utilize three of the existing Porter buildings in its expanded facility.

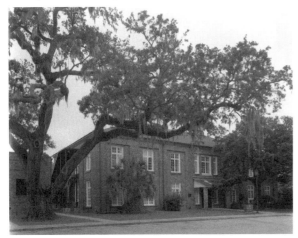

1990s — 45 B-2

Colcock Hall looks much the same as in earlier days except for the small shelter over the entrance. The handsome live oak, sometimes called Hervey Allen's oak to acknowledge the poem that author wrote in its honor, continues to stand guard by this old Confederate building, now joined by a palm. The building is presently used in conjunction with the nearby library.

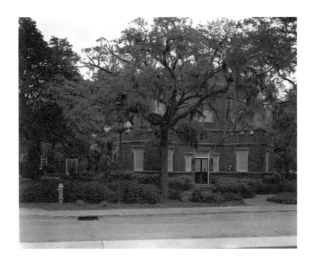

The Waring Historical Library, renamed for Joseph I. Waring, M.D., its first director, has changed little in its appearance. It houses the Medical University's rare books, historical papers, and museum objects relating to medicine.

1990s — 45 B-3

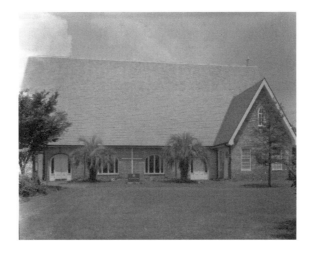

St. Luke's Chapel, now named for Luke the physician, continues to provide a spiritual facility on campus and has become a revered place for students and faculty of MUSC. Its remarkable recovery from near ruin is shown on the two following pages.

1990s — 45 B-4

Porter-Gaud occupies an attractive campus at Albemarle Point across the Ashley River from old Porter Military Academy. It has gained high respect and a national reputation for scholarship.

1990s — 45 B-5

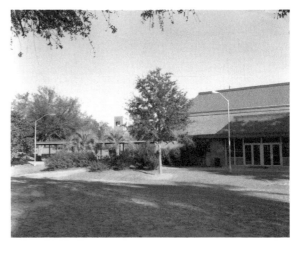

St. Luke's Chapel at the Medical University of South Carolina must provide one of Charleston's most remarkable restorations. It had been built in the 1820s as part of the Federal Arsenal and was used by the United States Federal government until 1861, and then by the Confederates, in the fabrication of artillery pieces. Caissons and cannons entered the building from Ashley Avenue through two large arches. These have been bricked in but their patterns in the wall are still visible from Ashley Avenue.

When Doctor Porter acquired the property for his school in 1880 he converted the building to a chapel, which he named St. Timothy's. He literally raised the roof and it became a place of worship for countless Porter boys. In 1964 MUSC purchased the Porter site, an entire city block, and renamed the chapel St. Luke's. Medical personnel developed a strong bond with the historic building, some were married there, and it was brought into excellent condition.

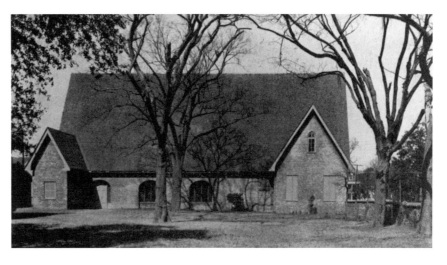

1890s — 46 A-2

St. Luke's Chapel when it was St. Timothy's in the early days of Porter Military Academy.

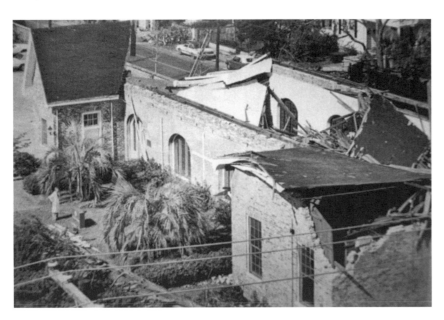

1990s — 46 A-1

Hurricane Hugo's damage to St. Luke's Chapel is surveyed by Doctor Worthington of MUSC.

On September 21, 1989, St. Luke's Chapel looked as it is pictured on the previous page. The next morning it looked as it is shown at left. Hurricane Hugo's damage to the building, its stained glass windows, and all of its contents was so severe that the possibility of this repair seemed remote. Thus the announcement by Dr. James B. Edwards, President of MUSC, that St. Luke's Chapel would definitely be restored was widely welcomed. The restoration committee, chaired by Dr. W. Curtis Worthington, gathered valuable fragments from the rubble as it was cleared. Plans were carefully made, funds secured, and in time restoration was begun. Whenever possible original materials were used in rebuilding, including most of the stained glass. Progress continued during the next four years as shown on the page at right recorded by PMA alumnus and historian, Thomas L. Ilderton. Finally work was finished. St. Luke's Chapel was rededicated February 1994 completing a remarkable restoration.

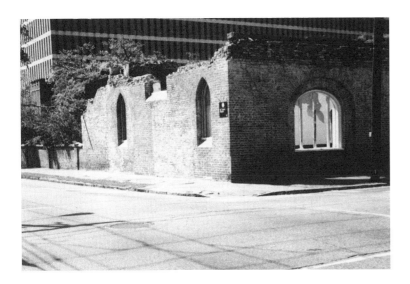

1990s — 46 B-1

St. Luke's Chapel, fragile and damaged by Hurricane Hugo, seems to be securing symbolic protection from the large MUSC building behind.

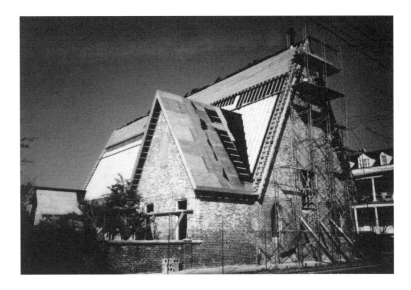

1990s — 46 B-3

Gothic roof timbers rising into the heavens appear to proclaim the coming rebirth of St. Luke's Chapel.

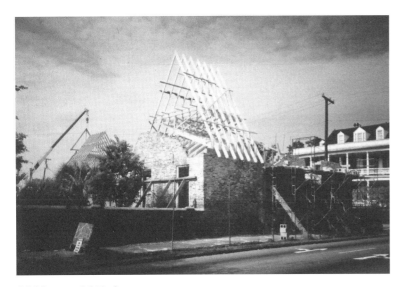

1990s — 46 B-2

A familiar landmark now more securely built to resist hurricanes is reappearing on the corner of Ashley Avenue and Bee Street.

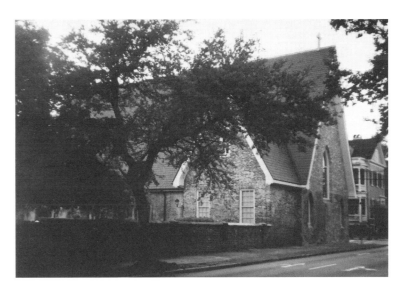

1990s — 46 B-4

After four years of dedicated work St. Luke's Chapel, MUSC, has been handsomely restored to its time-honored place on the campus.

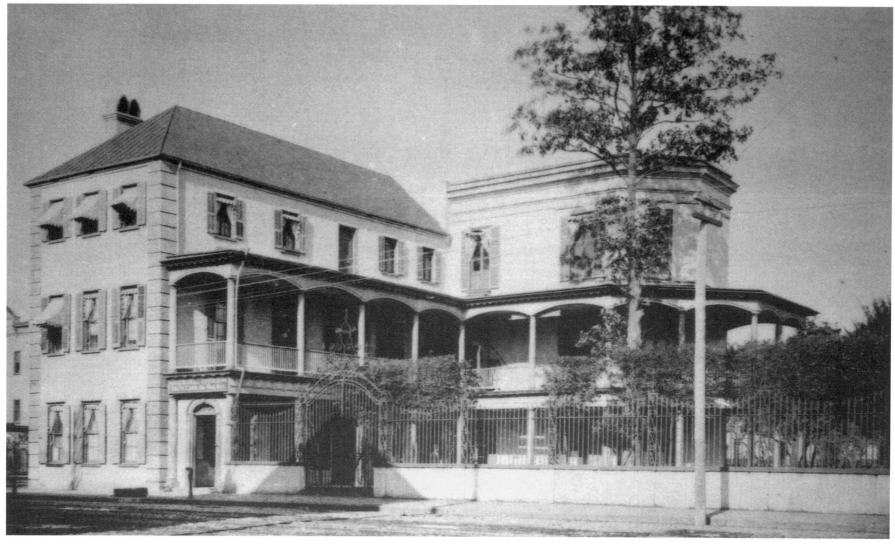

1890s — 47

Formerly the home of William Aiken, this residence at the corner of King and Ann Streets, with its generous piazzas, had by 1890 become general offices for the South Carolina Railroad Company. Aiken, who built the house between 1807 and 1811, was the first president of the South Carolina Canal and Railroad Company. On Christmas Day in 1830, the company's steam locomotive "Best Friend" became the first in America to pull a train on a track in regular service, and by 1833 made regular runs to Hamburg, South Carolina, just across the Savannah River from Augusta, Georgia. During the 1830s this was the longest rail line in the nation.

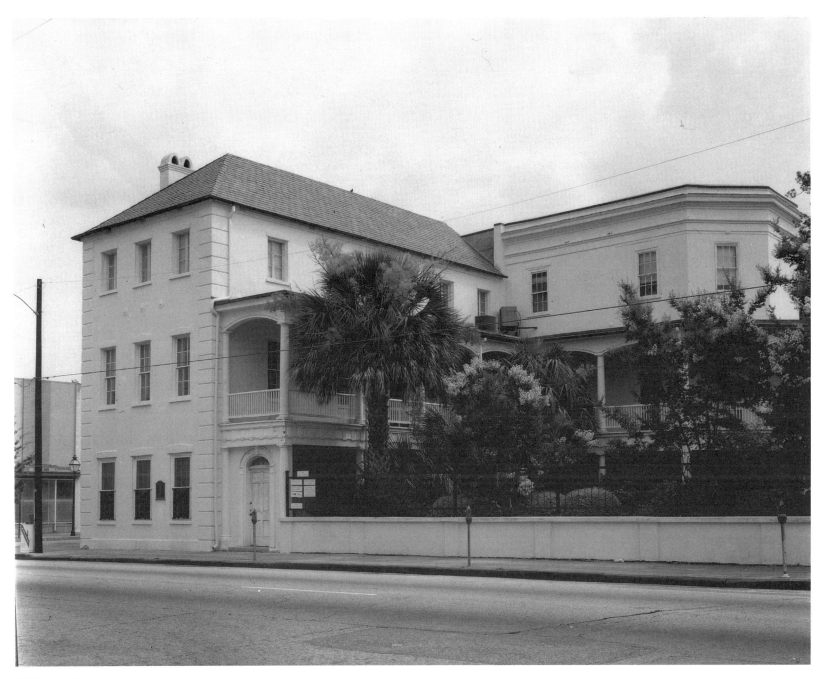

1990s — 47

The Aiken House at 456 King Street continues to serve Charleston and the South. The National Trust for Historic Preservation has located its southern regional office there, and several other important organizations are also housed in this 184-year-old building.

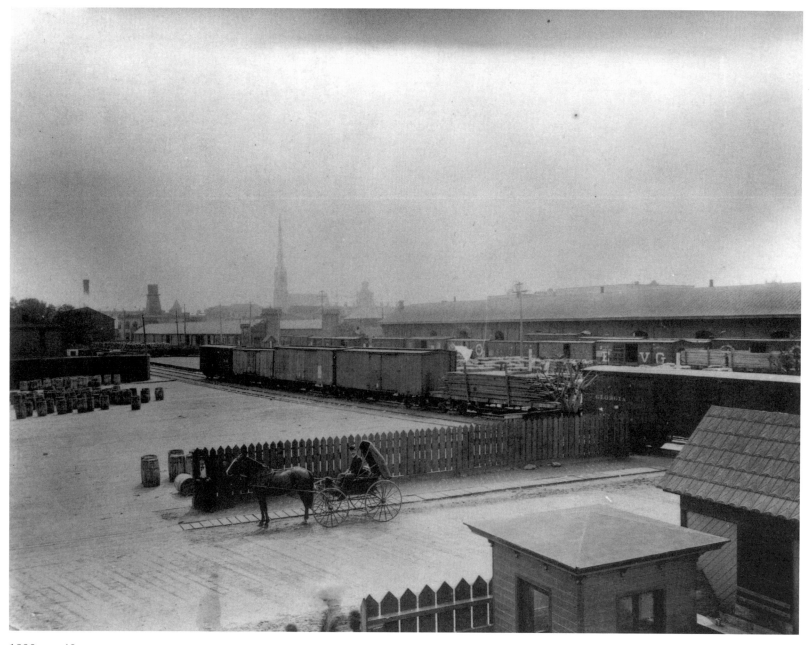

1890s — 48

Cotton and freight yards of the South Carolina Railroad as they appeared in the 1890s, looking southwest from the corner of Mary and Meeting Streets—The steeple of Saint Matthew's Church is seen through the haze created by numerous smokestacks.

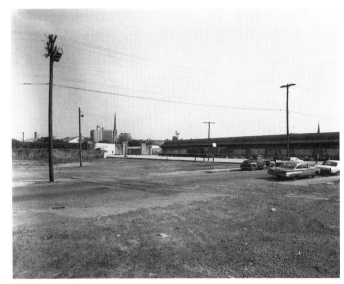

The old freight yards are alive with activity in the 1990s, and an area long neglected is now the site of such major buildings as the Visitors' Center complex and an attractive telephone company office structure. The long railroad warehouse with its fascinating curved roof now serves such diverse groups as the Chamber of Commerce, United Way, and The Music Farm. This area seems destined for continued growth.

1970s — 48

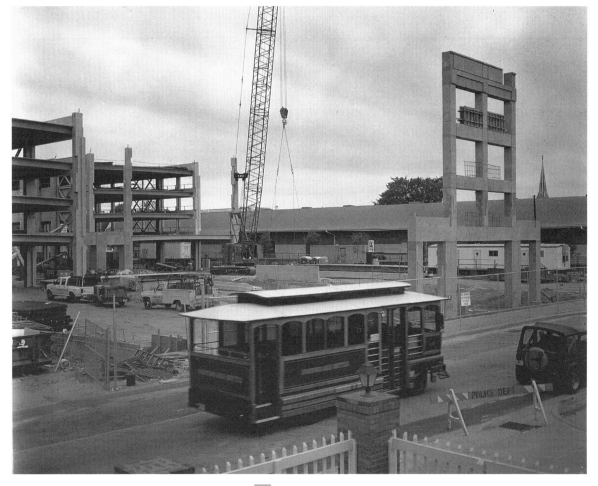

1990s — 48

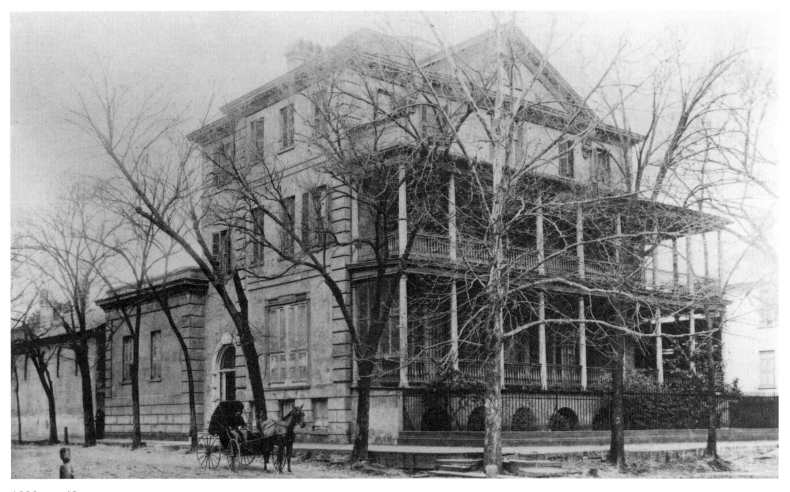

1890s — 49

The Aiken Mansion, built during the 1820s for the Robertson family, was later purchased by Governor William Aiken, Jr., of South Carolina. Jefferson Davis, president of the Confederacy, was a guest here when he visited Charleston in 1863. The waiting buggy perhaps provided transportation for the roving photographer on his rounds of the Charleston area.

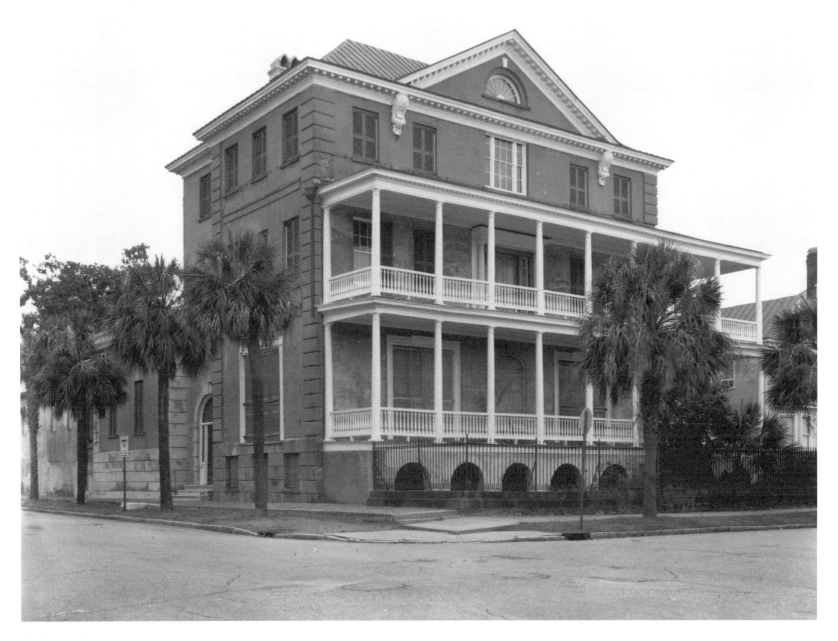

1990s — 49

The Aiken-Rhett House at 48 Elizabeth Street has regained much of its early splendor in recent years. It is associated with the Charleston Museum and while not open at present would seem to have considerable potential as this area increases in importance.

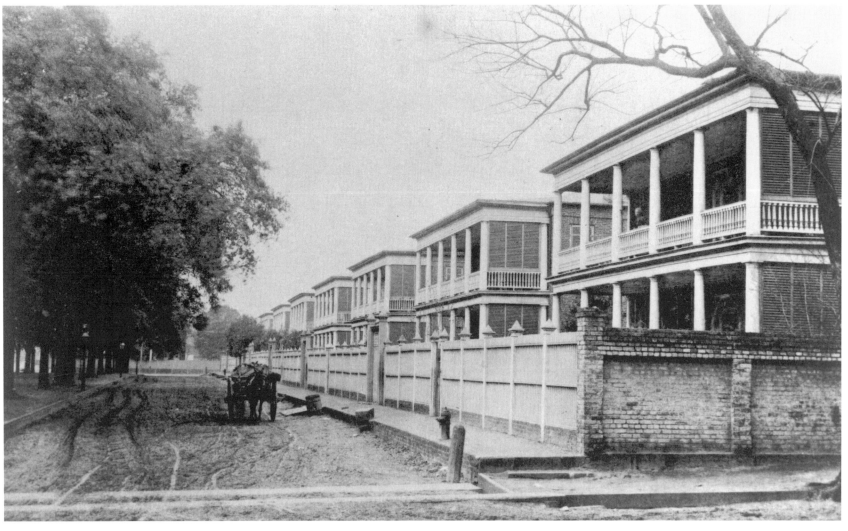

1890s — 50

These look-alike houses on Wragg Street could offer their 1890s residents the shade of Wragg Mall across the street. It is said that they belonged to the owner of the adjacent Aiken mansion, and were known as "The Seven Days of the Week," rental income of each home providing for one day's expenses at the mansion.

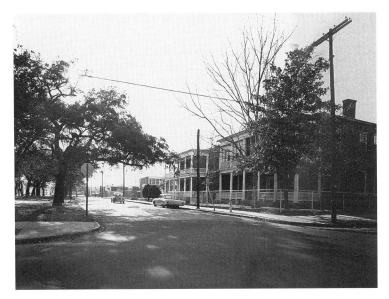

The two remaining antebellum houses on Aiken's Row continue in use as residences. At the near house an attractive iron and brick fence has been installed.

1970s — 50

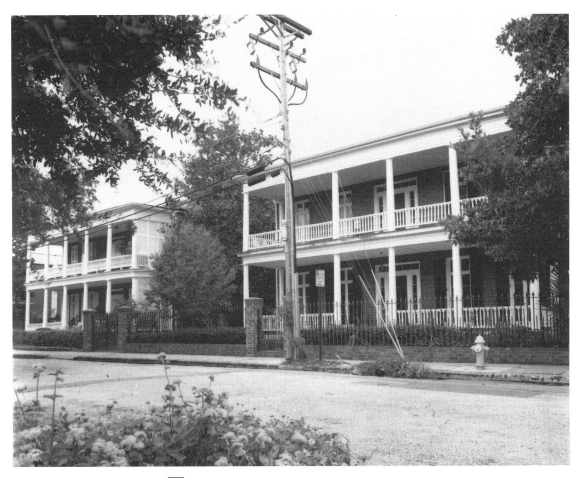

1990s — 50

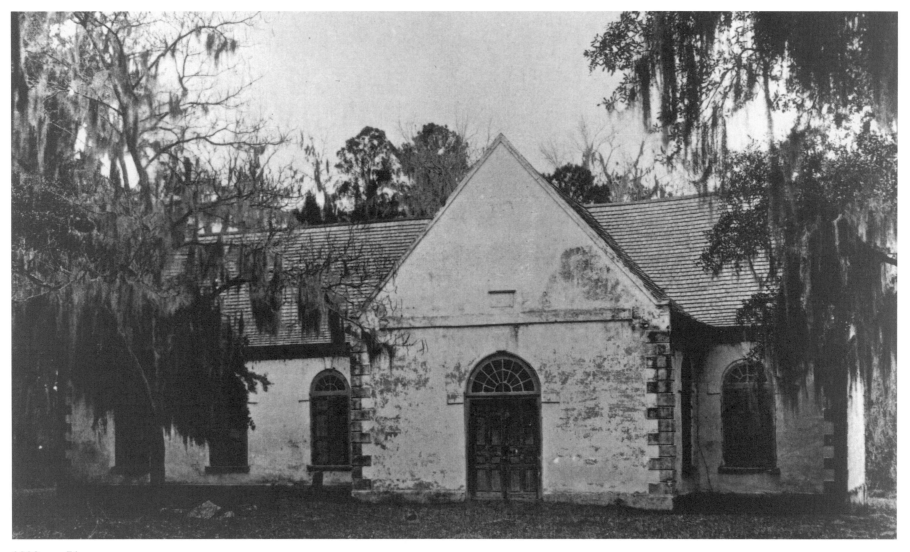

1890s — 51

Saint Andrew's Church on the Ashley River Road (S.C. Highway 61) dates from 1706. In that year the Church of England was established by law in the colony and boundary lines were drawn for ten parishes including Saint Andrew's. The oldest example of Episcopal architecture in South Carolina, the nave was developed into its present cruciform in 1723 with the addition of chancel and transepts. Missionary work among Blacks and Indians was carried on here from an early date. During the period when indigo was in demand, Saint Andrew's was one of the wealthiest parishes in South Carolina, but its congregation, suffering from attacks by Indians and from the effects of wars, gradually dwindled, and in 1891, shortly before this photograph was made, the church was closed.

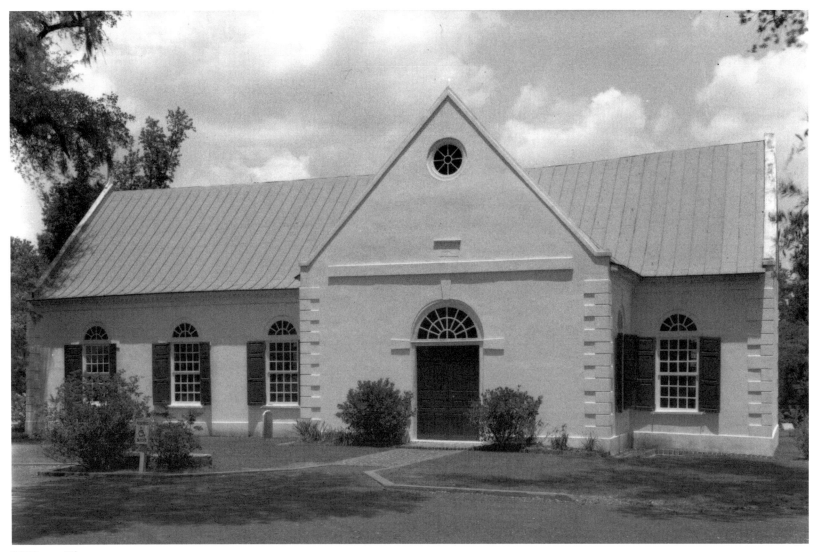

1990s — 51

As its age increases Saint Andrew's Episcopal Church looks progressively younger. The earlier shingles have been replaced by a metal roof, the window-blinds have been opened, and paint and foundation-planting have enhanced its appearance. A wheel window has been placed in the west transept gable. The church was reopened in 1948 as the population of the parish grew, and extensive renovations were carried out in 1969. During recent years attractive housing developments have sprung up along the River Road and the Church's membership has increased accordingly.

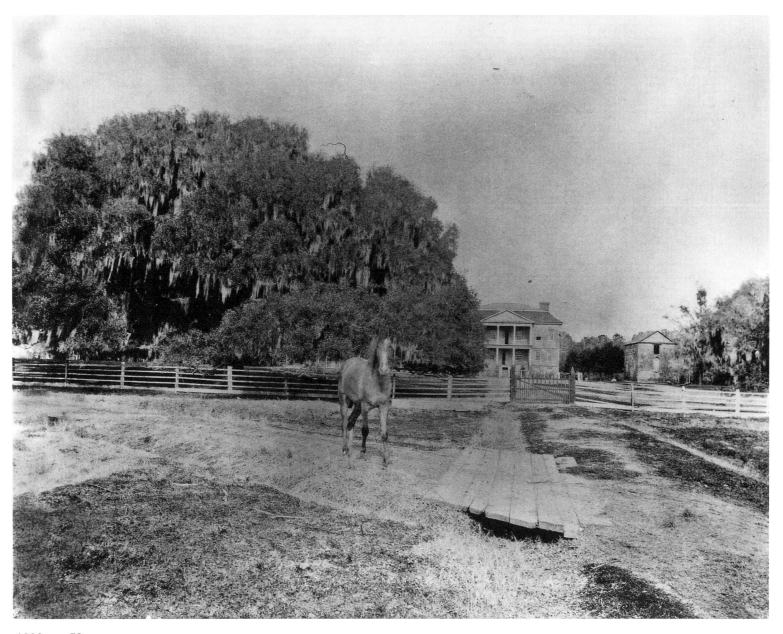

1890s — 52

Drayton Hall as it looked in the 1890s—The Draytons had settled at Magnolia (Gardens) about 1700, and the mansion was built by John Drayton, a member of His Majesty's Council, between 1738 and 1742, in the Palladian-villa style of Georgian architecture. During this period of immense wealth in the area, landowners along the Ashley River were joined in friendly rivalry to develop the finest of homes and gardens. Much later, in 1865, when devastation by enemy troops surrounded it, Drayton Hall was saved from the fiery fate of many of its neighbors by virtue of its being used as a hospital for those with smallpox.

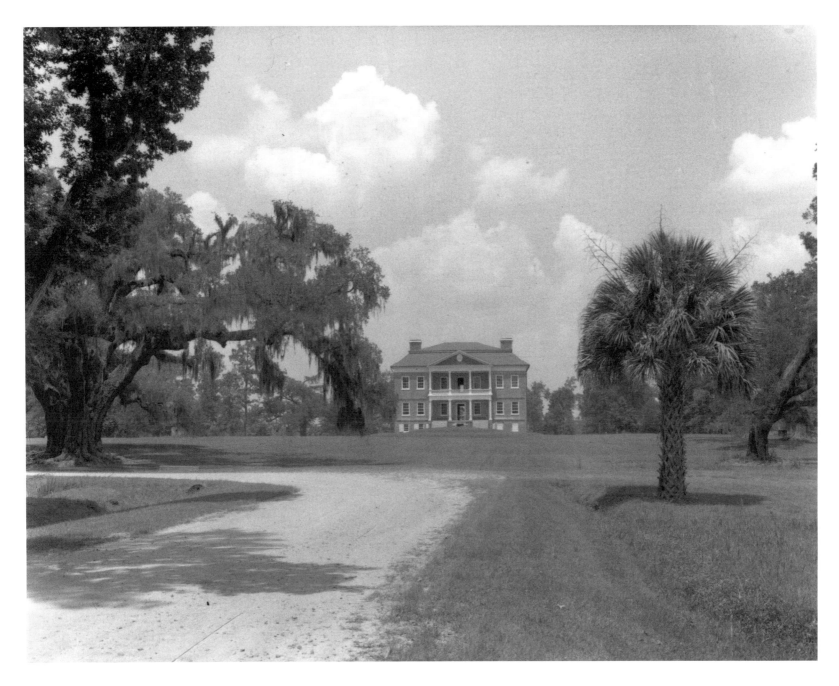

1990s — 52

Drayton Hall, having passed the two-and-a-half-century mark, looks especially stately as it continues to attract visitors from across America and beyond. They delight in seeing a colonial mansion that remains basically unchanged since it was built. With no electric lighting, running water, or central heating it is a true representative of its eighteenth-century past. Drayton Hall is now a property of the National Trust for Historic Preservation.

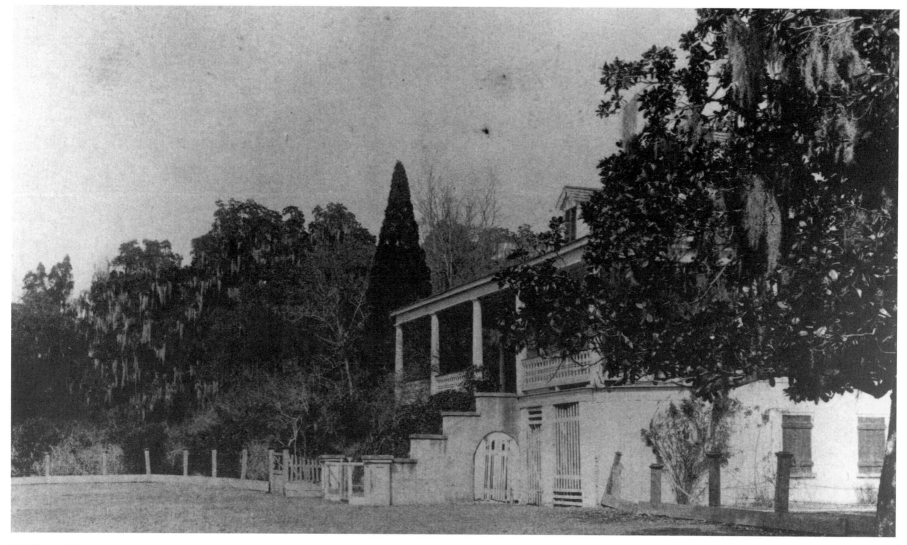

1890s — 53

"The Cottage" at Magnolia Gardens, built by the Draytons on their plantation estate—Magnolia-on-the-Ashley has been owned by nine generations of the family, since before 1700. The gardens were developed by the Reverend John Grimke-Drayton in the 1830s and 40s, at which time he was also serving at Saint Andrew's Church. He inherited Magnolia from his maternal grandfather by taking the surname Drayton. The original brick mansion was accidentally destroyed by fire after the Revolution. A second house was burned by Federal troops at the end of the Civil War. The third house on this site, built during Reconstruction, incorporates the old steps salvaged from its predecessor.

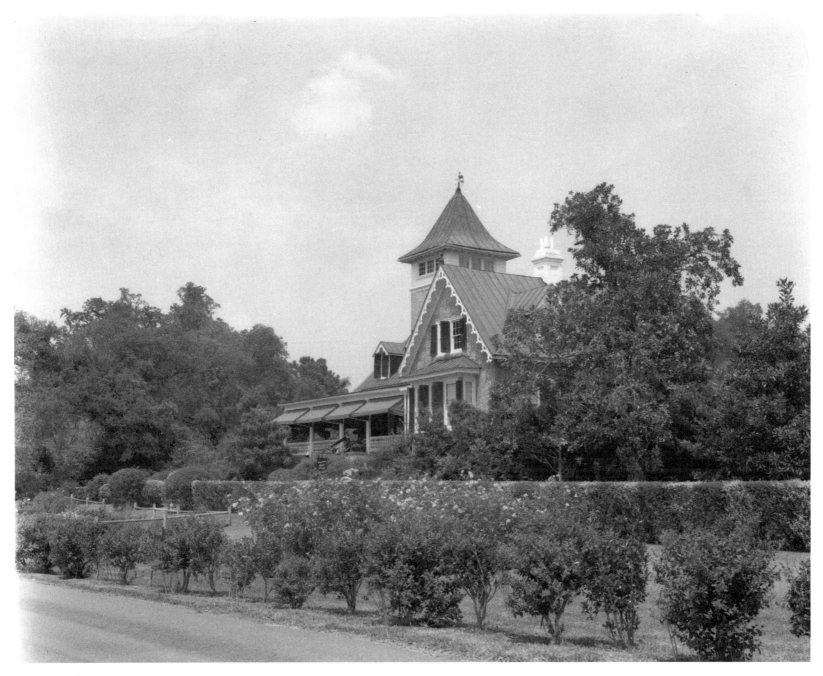

1990s — 53

The Plantation House at Magnolia Gardens displays an interesting assortment of roofs above the landscaped foliage. A recent addition to the plantation is the "Audubon Swamp Garden" where water-seeking wildlife provide a new attraction to the thousands of visitors who come every year.

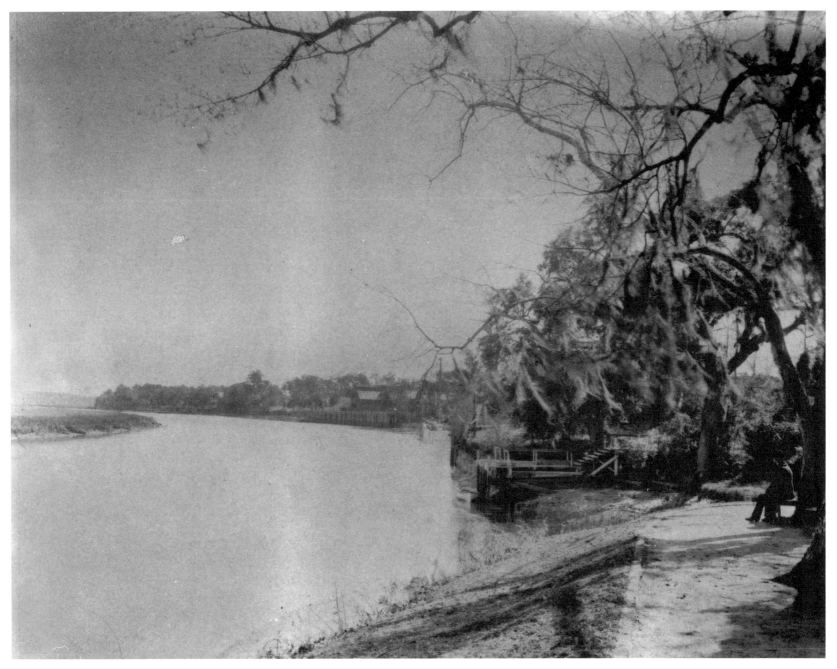

1890s — 54

The Ashley River was pleasant to view from Magnolia Gardens in the 1890s, even on a winter's day. Southward beyond the closest boat dock is the landing at Drayton Hall, and seventeen miles further downstream is Charleston's Battery. Over these waters produce from plantations on the Ashley was transported to the city in the early days.

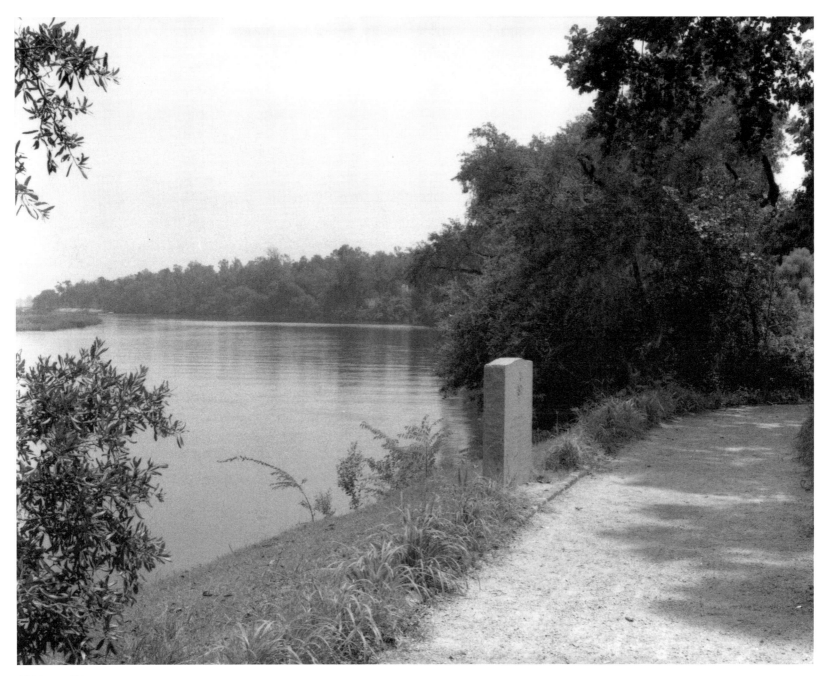

1990s — 54

The path by the Ashley River continues to offer garden visitors an appealing walkway. The monument seen in this photo was erected in 1980 in memory of Henry Woodward, Surgeon and Lords Proprietor's Deputy, who lived between 1646 and 1686.

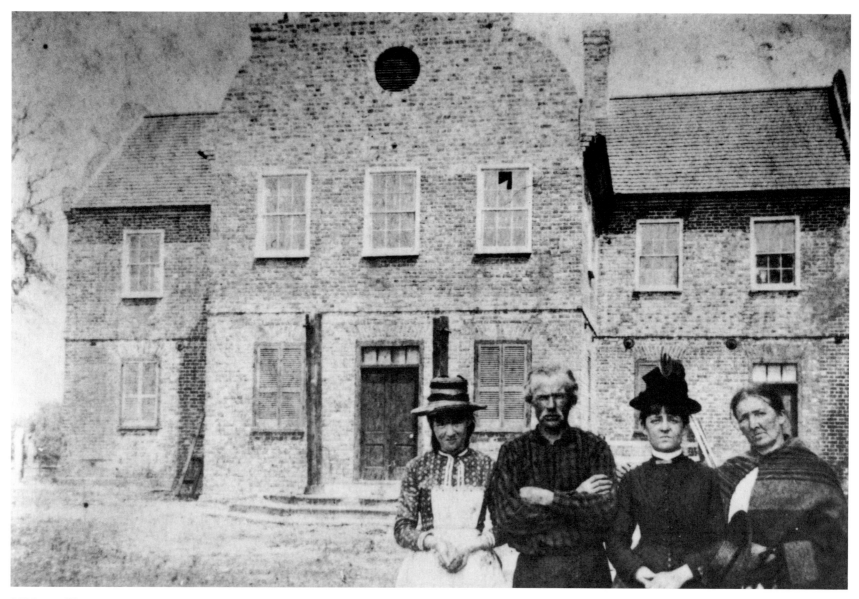

The South Wing at Middleton Place, saved when the main house and north wing were completely destroyed by Federal troops in 1865, reflects an elegance despite the difficult period through which it had passed. At the time of this photograph, strip-mining of phosphate was being carried on in the area, and the people shown in the foreground are thought to be a miner and his family. Note the earthquake bolts (reinforcing rods used to tie together brick walls weakened by the earthquake of 1886), which are found in many brick structures of that period.

Although the early records of Middleton Place were destroyed during the Civil War, it is known that Henry Middleton, president of the First Continental Congress, added the wings to the main house in 1755, and at that time also developed the first landscaped gardens in America, having sent to England for a landscape architect qualified for such an assignment. The result was a formal garden of grand scale, incorporating the mansion and its wings, with a series of rolling terraces descending to the river.

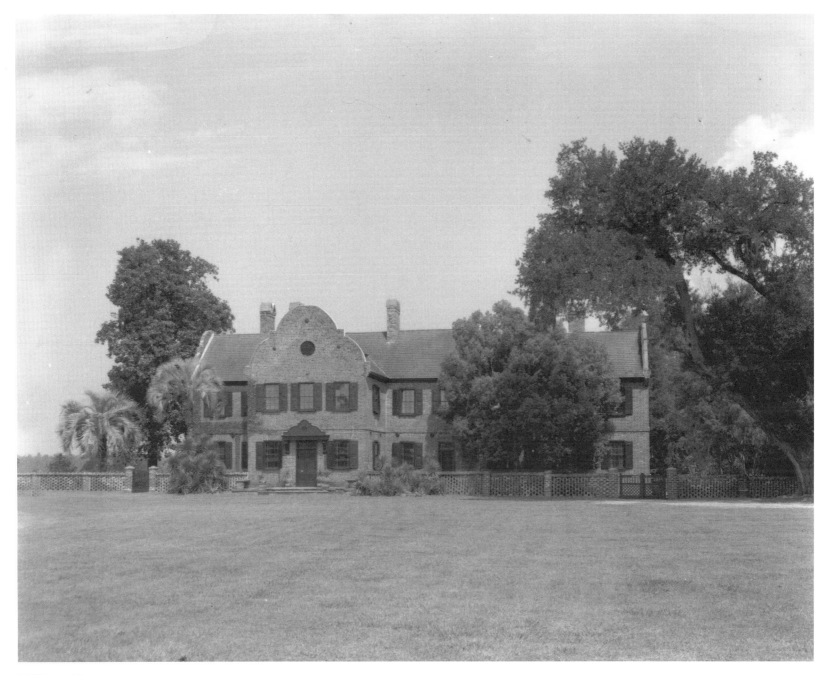

1990s — 55

The elegant setting of Middleton Place makes it a natural choice for holding group gatherings as well as the closing ceremonies of Charleston's annual Spoleto Festival. A visit to Middleton Gardens continues high on the lists of most visitors to Charleston.

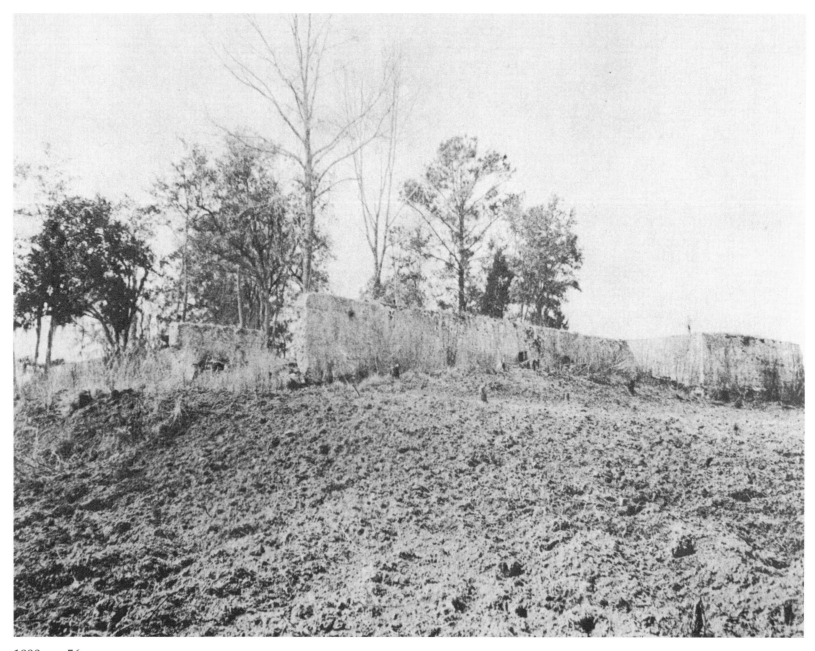

1890s — 56

Fort Dorchester was built of tabby (a primitive type of concrete with an oyster shell base) for protection from Indians, prior to 1719, by Congregationalists from Dorchester, Massachusetts, who settled in 1696 at this bluff twenty miles up the Ashley River from Charleston. The community moved to Georgia in the mid-1700s, probably for economic and health reasons, but the fort continued to be used throughout the Revolutionary War. General Francis Marion is said to have occupied it at one time.

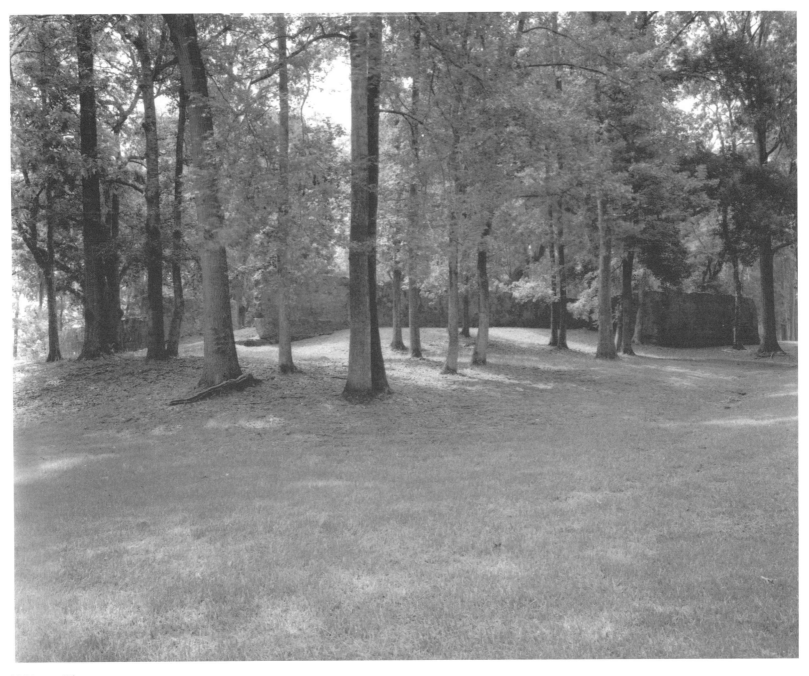

1990s — 56

Fort Dorchester State Park offers a serene setting in which early colonial history can be blended with imagination amid the wide tabby and brick walls of the old fort.

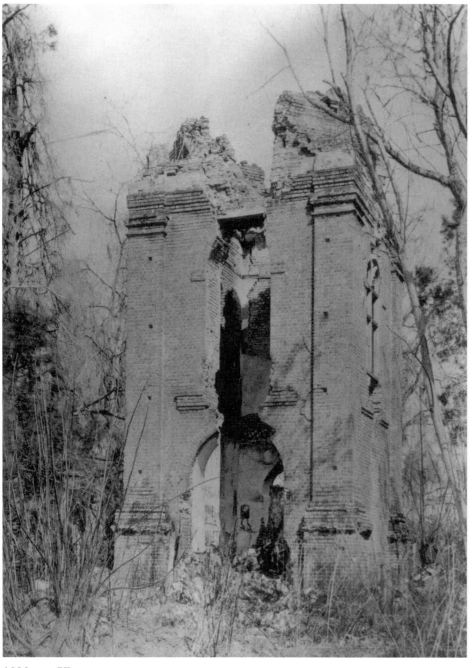

Ruins of Saint George's Church, Dorchester, as they were in the 1890s—Saint George's Parish was formed in 1719 from the upper part of Saint Andrew's Parish, and the church was probably built shortly thereafter. The town of Dorchester was abandoned by most of its inhabitants between 1752 and 1756, and the church fell into disuse. A close look inside the tower reveals that graffiti is not a twentieth-century invention.

1890s — 57

Saint George's Church tower continues to gain stability through the years under care of Dorchester State Park personnel. Missing bricks have been replaced and the grounds reflect a cared-for look.

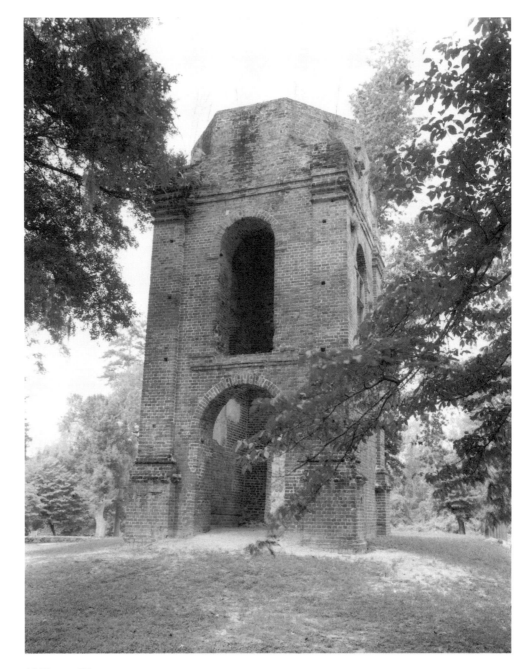

1990s — 57

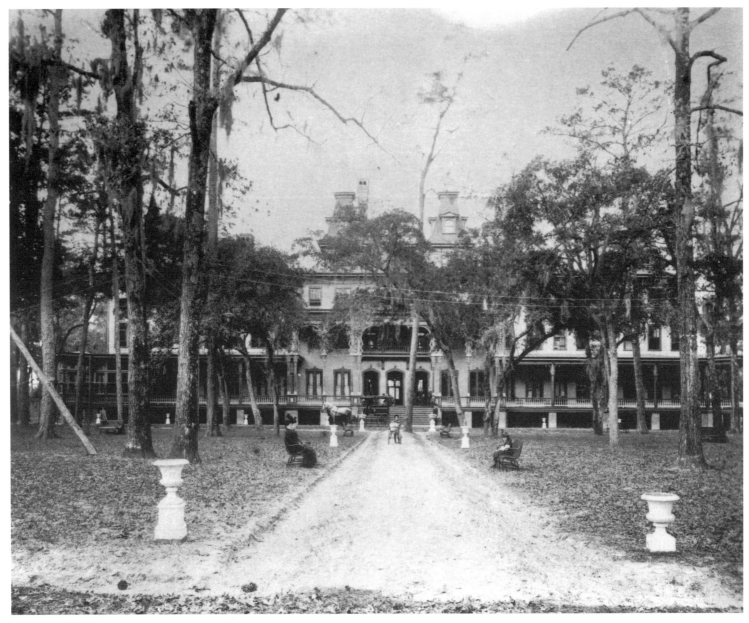

1890s — 58

Pine Forest Inn provided luxury accommodations during the 1890s to Summerville's winter visitors, mainly northerners seeking an early spring, who delighted in "The Flower Town of the South." Guests of the Inn were offered opportunities for golf, tennis, riding, driving, hunting, fishing, and touring such areas as old Fort Dorchester, or staying indoors by the cheerful open wood fires and enjoying the noted cuisine.

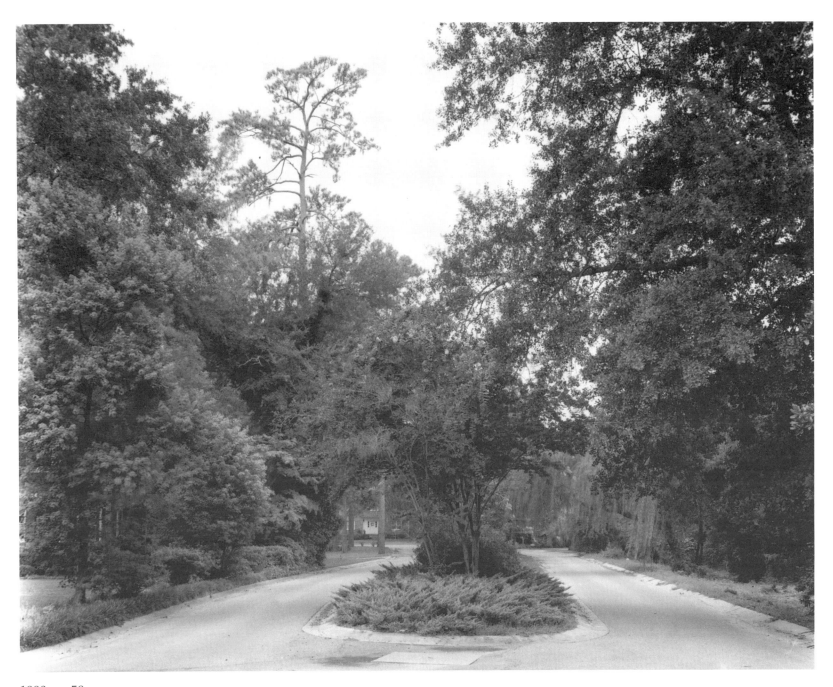

1990s — 58

The Pine Forest Inn, together with the Carolina and other delightful inns from Summerville's past, continue only as memories of days when the town's primary mission was to provide a garden haven to visitors from colder climes.

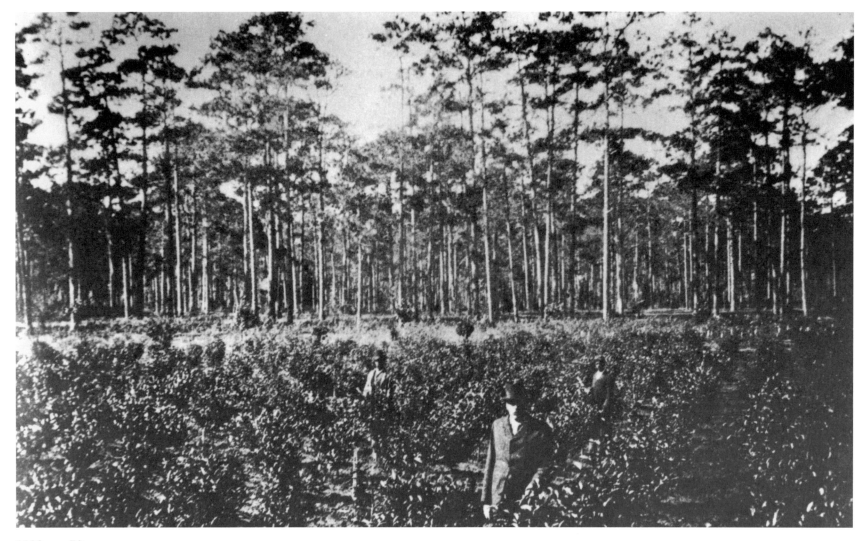

1890s — 59

The Pinehurst Tea Farm in Summerville was a place of renown when this photograph was made. Started in 1888 by Dr. Charles W. Shepard, the farm increased production yearly during the 1890s. Doctor Shepard hoped that his experiment would prove tea to be a commercially viable crop in America, although the farm was continually faced with competition from cheaper labor in the Orient. Probably the choicest and most delicately flavored of the teas grown was that called "sheltered tea," in which tea plants were covered by a netting erected on posts, and pine straw distributed over the netting to filter the sun's rays.

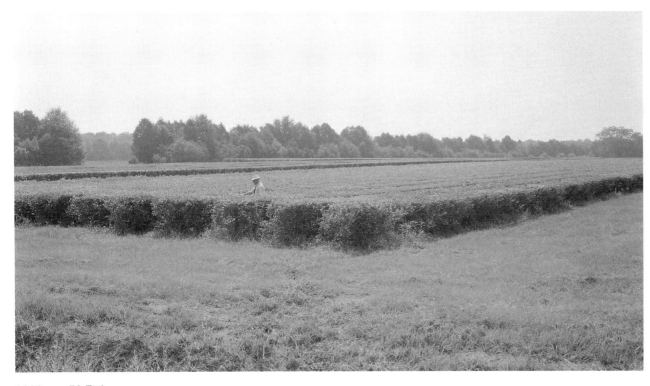

1990s — 59 B-1

The site of the Pinehurst Tea Farm continues as an attractive residential area in Summerville, but the tea farm itself now has a direct descendant. The Charleston Tea Plantation, located on Wadmalaw Island, produces "American Classic Tea." This is the only tea grown in America and uses plants derived from those at the old Pinehurst Tea Farm. Thus, history in the Charleston area continues to repeat itself.

1990s — 59 B-2

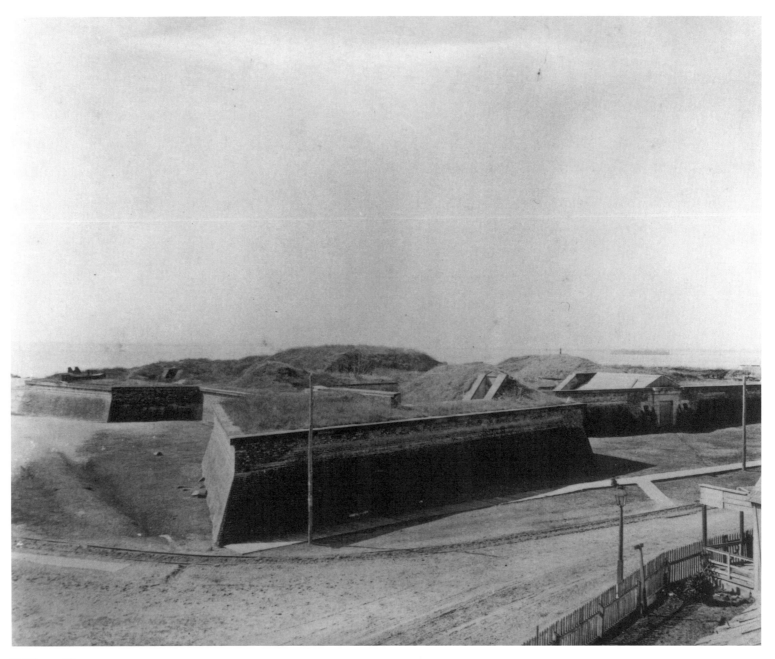

1890s — 60

Fort Moultrie on Sullivans Island, across the harbor from Charleston, as it appeared in the 1890s—The brick fortification was built in 1811 on the approximate site of the palmetto log fort which had repelled the British fleet in 1776. Fort Sumter is visible in the harbor above the main entrance. On the night of December 26, 1860, Major Anderson and his small Federal garrison left Fort Moultrie and traveled by boat to Fort Sumter, which he thought could be more easily defended. On April 11, 1861, General P. G. T. Beauregard sent an ultimatum to Anderson, an old friend from West Point, calling on him to evacuate Fort Sumter and receive safe conduct to the North. Anderson refused and at 4:30 AM on April 12, 1861, the War Between the States began.

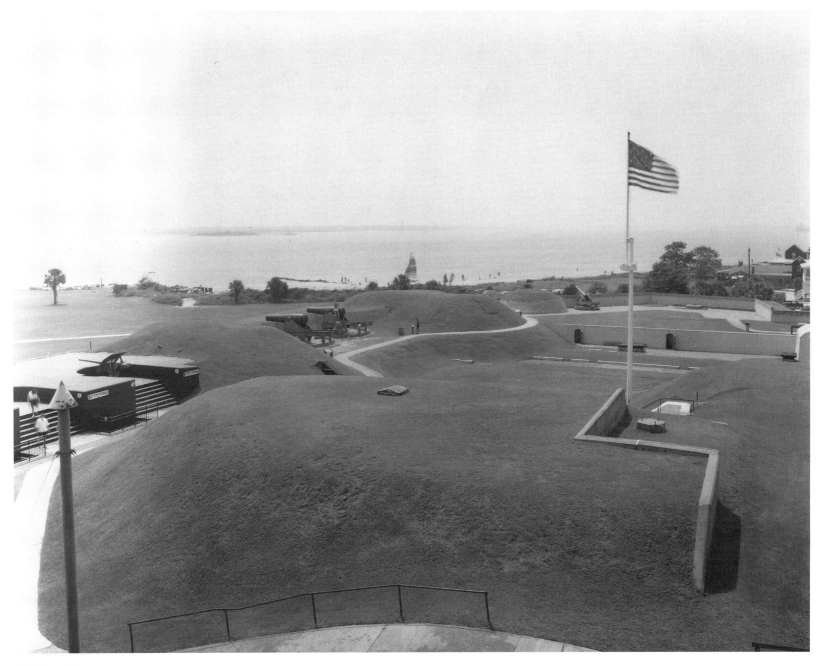

1990s — 60

Historic Fort Moultrie keeps peaceful watch over the entrance to Charleston harbor. Visitors wandering its grounds can look to sea where once eleven British warships under command of Admiral Sir Peter Parker were defeated by the guns of an unfinished fort made of palmetto logs, commanded by Colonel William Moultrie.

POSTSCRIPT

The pictures in this book show many fine structures that were photographed a century ago continuing to grace Charleston today. Some buildings appear in better condition now than then. This happy fact is due in substantial measure to the preservation movement that Miss Susan Pringle Frost began in 1920. For her inspired leadership, and for those who have continued to follow in her footsteps, we lovers of Charleston are deeply indebted.

In the early 1930s when this writer was a boy an opportunity was given to visit the King Street home of Susan Frost. There, Miss Susan herself provided us a tour of the historic Miles Brewton house. My grandmother, Lena Pinckney Hay, emphasized to me that this was a privileged occasion that should be remembered always. It has been.

Some years later my Hay grandparents provided the portfolio of 1890s photos, which was to become the basis of this book. In 1972 Jim Rhett and I began a work in which each old photograph was paired with a contemporary picture taken at the same site. The process has been repeated in 1995 and current photographs by Bob Rhett have been combined with those of his late father. The result is a continued comparative study of Charleston's physical relationship to time, and the success of her children as the city's custodians.

In any such undertaking as this the final result entails the help of many talented people. In the 1974 edition the early interest and encouragement of the late Mrs. Elizabeth O'Neill Verner and her daughter, Mrs. Elizabeth Verner Hamilton, were invaluable. And the perceptive comments on the architecture of Charleston by Sir Arthur Hay of Park, late superintending architect at Whitehall, London, reflect a genuine appreciation of the city. Throughout all phases of preparing the first book the assistance provided by Jim's wife, Nell, and by my wife, Jane, was indispensable.

In preparing this second edition Bob Rhett and I have received most welcomed support from the Preservation Society of Charleston, whose executive director, John W. Meffert, has kindly provided a thought-provoking preface on the invaluable contribution that preservation has made to Charleston. The Society's publications editor, Mary Moore Jacoby, and the Rev. Robert L. Oliveros have given most helpful suggestions and input. And Barbara Stone of Sandlapper Publishing Co., Inc., could not have been more cooperative as we all worked to get this in print. Our sincere thanks to each and all, including our wives, Kim Rhett and Jane Steele, who have made this work a pleasure.

Jack Steele

We acknowledge

the invaluable assistance given us by so many. A list of names to each of whom we are indebted would include our families and friends in such abundance as to greatly exceed the limits of this page. To each we extend our most sincere thanks. There are, in addition, several organizations and individuals without whose help this volume would have been less than complete.

We are grateful to

the late Sir Arthur Hay of Park, superintending architect at Whitehall, London, for his kindness in writing the foreword to this book.

the late Mr. and Mrs. Henry Cumming Hay, for their gift of the portfolio of 1890s photographs.

the late Miss Helen McCormick, whose knowledge and help cheerfully given is reflected in many parts of this book.

the late Mrs. Elizabeth O'Neill Verner and Dr. and Mrs. John A. Hamilton of the Tradd Street Press, for their comments and encouragement.

the South Carolina Historical Society, for the use of Photos 1890s—2, 1890s—24, and 1890s—39 and other valuable assistance.

Mr. Andrew S. Drury, for the use of Photo 1890s—32.

the Charleston *Post and Courier*, for the use of Photo 1990s—46 A-1.

Mr. Thomas A. Ilderton, for the use of Photos 1990s—46 B-1, B-2, B-3, and B-4.

Middleton Place, Mr. Charles H. P. Duell, and Mr. Alan Powell, for the use of Photo 1890s—55.

the city of Summerville, Mrs. Betty A. Sedivy, and Mrs. Mary B. Beauchene, for helpful data on the Pine Forest Inn.

Mr. John H. Tiencken, Jr., for his invaluable advice and comments.

LP Photographics, Mr. Gil Lipscomb, and Mr. Russell Pace, for help in producing the contemporary photographs for this volume.

finally, the Chicago photographer of long ago, whose visit to Charleston resulted in all but a very few of the 1890s photographs in this book.

the authors

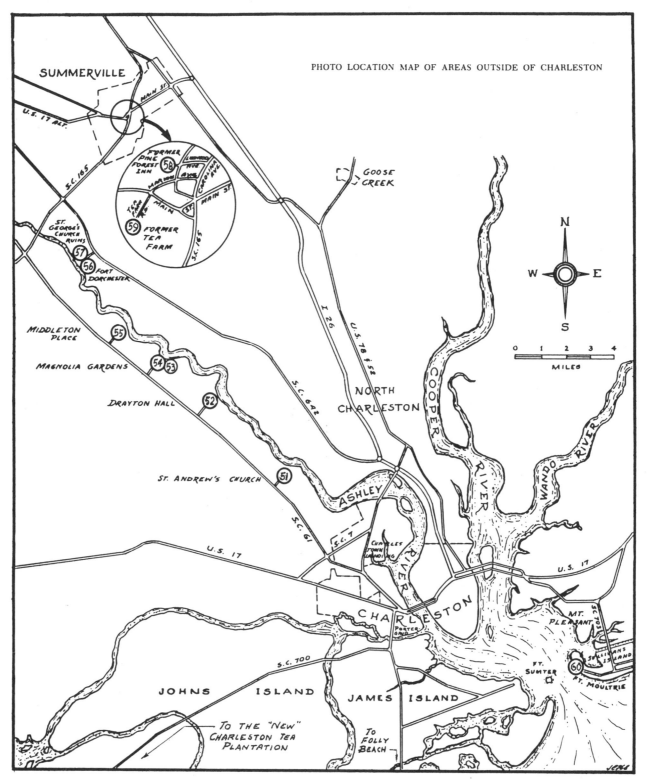

PHOTO LOCATION MAP OF AREAS OUTSIDE OF CHARLESTON